LIFE IN UK
TEST

入籍英國
考試全攻略

Koo Sir 著

英國入籍試題解 Easy Pass

Life in the UK Test（一般被稱為「英國入籍試」），無論你是持有以下何簽證：BNO5+1、居英權二代、配偶簽證、投資額簽證、企業家簽證、海外公司首席代表簽證、創新者簽證、工作簽證等，都必須通過Life in the UK Test，才可以申請永久居留權。

受試者必須在45分鐘內，回答24條選擇題，當中更需要18條全對。而最重要的是，試題的內容結合了當地的歷史、文化、政經、傳統習俗、法律和政治制度等多方面問題，例如：「蘇格蘭議會有多少個席次？」、「誰首先到達英國？」、「在第二次世界大戰中，哪部電影在提高士氣方面發揮了重要作用？」、「威爾斯鬆餅是用什麼造的？」等等。

這些問題對於連本地人都未必有把握可以取得滿分，更何況外來移民？有國際知名通訊社曾隨機調查了40名英國當地人，只有一半人可以悉數答對，足見程度之艱深。本書就是希望通過數百條題目反覆測試、不斷操練，幫有意永居及入籍英國的讀者，輕鬆搞定「入籍英國試」，讓大家都可以「1 Take Pass」！

英國五年，然後呢

2020年9月某天，終於應考Life in the UK test，也是以往俗稱的「英國入籍試」，其實現在大部分的英國簽證，在第五年向英國 home office 申請永久居留前，都必須要通過Life in the UK test，有了永久居留權的一年後，才能申請 Citizenship ，正式入籍

筆者也一步一腳印的完成這5年的每一項任務，2015年初首先以 NAR-IC 認證免考ITILES，然後用了整整8個月籌備英國企業家簽證，2015年11月初簽成功，2016年5月正式移居英國

2016年12月開展英國生意，必須在續簽前投放20萬鎊在營運上，並聘請2個本地人至少12個月，2019年3月續簽成功，再要聘請2個本地人至少12個月

最後終於也完成了 了很久很久的Life in the UK test，步出試場，感覺的是，這5年付出的所有所有，得來的真的不容易

相信 Tier 1 Entrepreneurs Visa 的同路人也會如是想,我們都是有血有汗有淚,對英國對社區盡力有貢獻,只因我們都有共同寄望

朋友問:「我的英文不好,Life in the UK test 難嗎?」我的回應是:只要平日多留意英國生活的日常和本地新聞,用心多做練習,應該不難應付吧

我在應考前都用了不少時間,反覆做了很多練習,不懂的,尤其是深度歷史題和文化題比較難應付,我都會上網再找中文資料,理解後更易明白

本書做到中英對照,使應考者更易理解題目和答案,比起我當日自己做的notes更佳,而且模擬試題像真度很高,應試者更有信心,要合格應該不難呢

祝大家都一次成功

<div align="right">

fb「香港人在英國專頁」版主 黎瑋思

fb@HongKongerInUK

</div>

目錄

PART THREE
模擬試卷 Mock Exam

PART FOUR
考生急症室

PART ONE
關於英國入籍試

LIFE IN THE UK TEST

1.1
什麼是
英國入籍試？

英國入籍試（Life in the UK Test），是一個由英國內政部於2005年推出，對於申請歸化入籍之非歐盟人士的英語語言和英國生活基本知識測試，2007年延伸到「永居申請」，並於2013年10月起成為所有永居和入籍申請所必須通過之考試。

Life in the UK Test，一般被稱為「英國入籍試」，無論是持有以下何簽證：BNO 5+1，居英權二代（British Citizen by Descent）、配偶簽證（Spouse Visa）、投資額簽證（Investor Visa）、企業家簽證（Tier1 Entrepreneur Visa）、海外公司首席代表簽證（Sole Representative Visa）、創新者簽證（Innovator Visa ）、工作簽證（Tier 2 General Work Visa）等等，都必須通過Life in the UK Test，才可以申請永久居留權，除非是18歲以下或65歲以上，才可豁免考試。

如何通過考試？

英國入籍試的考試結構及其簡單，全卷只有24道題，內含單選、多選、正誤判斷、正確項選擇4類題型。你只要在45分鐘內做對其中的

18道題（75%）就可以通過考試。所以，通過有效地指導，針對性的培訓，達到一定量的訓練，絕對可以通過life in the UK考試。

考試形式

英國生活測試包括24個有關當今英國生活重要方面的問題。您將在電腦上進行測試，並在45分鐘內完成所有問題。為了通過測試，您必須正確回答18個問題。這些問題基於英國生活的各個方面。

題目類型

測試中有四種類型的問題：

a. **四選一**：從四個選項中選擇一個正確答案。

以下是示例：

Which is the most popular sport in the UK?

（A）Football

（B）Rugby

（C）Golf

（D）Tennis

b. **正誤題**：確定陳述是對還是錯。

以下是示例：

Is the statement below TRUE or FALSE?

The daffodil is the national flower of Wales.

c. 二選一：從兩個陳述中選擇一個您認為正確的陳述。

以下是示例：

1. Which of the following statements is correct?

（A）Shakespeare wrote 'To be or not to be'

（B）Shakespeare wrote 'We will fight them on the beaches'

d. 四選二：從四個選項中選擇兩個正確答案。您需要選擇兩個正確答案才能對此類問題有所了解。

以下是示例：

Which TWO political parties formed the coalition government in 2010?

（A）Conservatives

（B）Labour

（C）Communists

（D）Liberal Democrats

PART TWO
題庫練習

PRACTICE QUESTIONS

2.1
四選一題
Select One Correct Answer From Four Options

1. In what we call the 'Stone Age', who was the first person to arrive in Britain?

 在我們所指的「石器時代」中，誰首先到達英國？

 （A）Indians印第安人

 （B）Hunter-gatherers狩獵採集者

 （C）Fishermen漁夫

 （D）Pirates海盜

2. The Queen Elizabeth period is famous for its rich poems and plays, especially which playwright's plays and poems?

 伊莉莎白女王時代以其豐富的詩歌和戲劇聞名於世，哪個劇作家的戲劇和詩歌在當時最有名？

 （A）Alexander Dumas亞歷山大仲馬（大仲馬）

 （B）William Shakespeare威廉莎士比亞

 （C）Charles Dickens狄更斯

 （D）Alexandre Dumas fils小亞歷山大·仲馬（小仲馬）

3. **Which of the following is not a basic principle of life in the UK?**

 以下哪項不是英國生活的基本原則？

 （A）Democracy民主

 （B）The rule of law法治

 （C）Autocracy專制

 （D）Individual liberty個人自由

4. **Which flag of the followings is famous for its diagonal red cross on the white ground?**

 以下哪支旗幟是以白色底色上有一個對角的紅色交叉聞名？

 （A）The cross of St George, patron saint of England 英格蘭的守護聖者聖喬治

 （B）The cross of St Patrick, patron saint of Ireland愛爾蘭的守護聖者聖巴德利爵士

 （C）The cross of St David, patron saint of Wales威爾斯的守護聖者聖大衛

 （D）The cross of St Andrew, patron saint of Scotland蘇格蘭的守護聖者聖安德肋

5. **Where does Swansea City locate in?**

 史雲斯市位處以下哪個地方？

 （A）England英格蘭

 （B）Scotland蘇格蘭

 （C）Wales威爾斯

 （D）None of the above以上皆否

6. **When is Christmas Eve celebrated?**

 平安夜是在什麼時候慶祝的？

 （A）December 22十二月二十二日

 （B）December 24十二月二十四日

 （C）December 25十二月二十五日

 （D）December 26十二月二十六日

7. **Which British athlete won 5 consecutive gold medals in the Olympic rowing event?**

 哪位英國運動員在奧運會賽艇比賽中連續五次獲得金牌？

 （A）Sir Chris Hoy克里斯·霍伊爵士

 （B）Christopher Dean基斯杜化·甸恩

 （C）Bill Jones比爾·鍾斯

 （D）Sir Steve Redgrave史蒂夫·雷德格雷夫爵士

8. **Who was the inventor of the WWW (World Wide Web)?**

 誰是萬維網的發明者？

 （A）Sir Tim Berners Lee蒂姆爵士

 （B）Sir Charles Kuen Kao高錕

 （C）Sir Ian Wilmot伊恩·威爾穆特爵士

 （D）Sir Bernard Lovell伯納德爵士

9. Which hill fort from the Iron Age can be seen in Dorset?

 在多塞特郡可以看到鐵器時代的哪座山堡？

 （A）Edinburgh Castle愛丁堡城堡

 （B）Caernarfon Castle卡那封城堡

 （C）Hogwarts Castle霍格華茲城堡

 （D）Maiden Castle梅登城堡

10. Before the 18th century, what was the largest source of employment in Britain?

 在18世紀之前，英國最大的就業來源是什麼？

 （A）Shipbuilding industry造船業

 （B）Agriculture農業

 （C）Opium trading鴉片貿易

 （D）Manufacturing製造業

11. SECC (Scottish Exhibition and Conference Centre) locates in:

 SECC（蘇格蘭會展中心）是位於：

 （A）Aberdeen鴨巴甸

 （B）Glasgow格拉斯哥

 （C）Scotland Yard蘇格蘭場

 （D）Dundee登地

12. In the second half of the 19th century, a group of important artists painted detailed pictures of religious or literary themes in bright colors. These are called:

在19世紀下半葉，一群藝術家以鮮豔的色彩繪製了宗教或文學主題的畫作，我們將之稱為：

（A）The Pre-Raphaelites前拉斐爾派

（B）Suffragettes婦女參政運動者

（C）Chartists憲章運動

（D）None of the above以上皆否

13. The Treaty of Rome established _____ in 1957.

1957年《羅馬條約》建立了：

（A）the European Economic Union歐洲經濟聯盟

（B）the European Trading United歐洲貿易聯盟

（C）United Nations聯合國

（D）None of the above以上皆否

14. Who has written a series of famous poems, telling the story of a group of people going to Canterbury towards the pilgrimage destination of the "The Canterbury Tales"?

誰寫了一系列著名的詩歌，講述一群人前往坎特伯雷朝聖的故事《坎特伯雷故事集》？

（A）William Shakespeare威廉·莎士比亞

（B）Geoffrey Chaucer傑弗里•喬叟

（C）Aesop伊索

（D）Charles Dickens狄更斯

15. Which famous poem tells the story of the Arthurian court knight?

哪部著名的詩歌講述亞瑟王朝廷騎士的故事？

（A）Beowulf貝武夫

（B）Paradise Lost失樂園

（C）Sir Gawain and the Green Knight高文爵士與綠騎士

（D）Troy木馬屠城記

16. How old was Mary Stuart, the Queen of Scots when she became Queen?

蘇格蘭女王瑪麗·斯圖亞特成為皇后時有多大？

（A）Three years old三歲

（B）Two months old一個月大

（C）A week old一星期

（D）15 years old十五歲

17. During World War II, which of the following films played an important role in boosting morale?

在第二次世界大戰期間，以下哪部電影在提高士氣方面發揮了重要的作用？

（A）The Ladykillers老婦殺手

（B）1942一九四二

（C）Passport to Pimlico買路錢

（D）In Which We Serve與祖國同在

18. What is the name of the building where the Welsh Assembly members met?

在威爾斯議會，議員會面的建築物叫什麼名字？

（A）Westminster西敏寺

（B）Stormont斯托蒙特城堡

（C）Holyrood荷里路德宮

（D）Senedd威爾斯議會大樓

19. What was the estimated population of the British Empire during the Victorian period?

在維多利亞時期，英國的估計人口有多少？

（A）More than 200 million people超過2億人

（B）More than 300 million people超過3億人

（C）More than 400 million people超過4億人

（D）More than 500 million people超過5億人

20. Which British female athlete won two gold medals (running) in the 2004 Olympics?

哪位英國女運動員在2004年奧運會上，獲得兩面賽跑金牌？

（A）Tim Henman漢文

（B）Jayne Torvill 珍·托維爾

（C）Dame Kelly Holmes凱莉·福爾摩斯夫人

（D）Jessica Ennis-Hill 謝茜嘉·恩尼斯·希爾

21. **Which of the following is not a 20th century British invention?**

 以下哪個不是20世紀英國的發明？

 （A）The radar雷達

 （B）The Turing machine圖靈機

 （C）The World Wide Web萬維網

 （D）Radioactivity放射性

22. **Which flower is related to Scotland?**

 哪朵花跟蘇格蘭有關？

 （A）Rose玫瑰

 （B）Thistle薊花

 （C）Daffodil黃水仙花

 （D）Shamrock三葉草

23. **Which of the following is the basic principle of life in the UK?**

 以下哪項是在英國生活的基本原則？

 （A）Rule of men人治

 （B）Personal freedom個人自由

 （C）Intolerance of those with different beliefs對不同信仰的人的不包容

 （D）Lack of social cohesion缺乏社會凝聚力

24. Where is the central landmark of the anniversary service?

週年紀念服務的中心地標在哪？

（A）Cardiff, Wales威爾斯卡迪夫

（B）Whitehall, London倫敦白廳

（C）Hounslow Heath, London倫敦豪士羅

（D）Piccadilly Circus, London倫敦皮卡迪利圓環

25. What is the Welsh cake made of?

威爾斯鬆餅是用什麼造的？

（A）Suet, onions and oatmeal羊脂、洋蔥和燕麥片

（B）Flour, dried fruits and spices麵粉、乾果和香料

（C）Potatoes, vegetables, Yorkshire puddings馬鈴薯、蔬菜、約克布甸

（D）Bacon, eggs, sausage, black pudding and potato bread煙肉、雞蛋、香腸、黑布甸和馬鈴薯麵包

26. Since 1952, which famous murder-mystery play has been running in the West End of London, and has had the longest initial run of any show in history?

自1952年以來，哪部著名的謀殺懸疑劇在倫敦西區劇院播出，並且是歷史上最長的首映儀式？

（A）The Phantom of the Opera歌聲魅影

（B）The Mousetrap捕鼠器

（C）Evita貝隆夫人

（D）Titanic鐵達尼

27. How were Elizabeth I and 'Mary, Queen of Scots' related?

伊莉莎白一世和蘇格蘭女王「瑪麗一世」之間有著什麼關係？

（A）cousins表親關係

（B）sisters姐妹關係

（C）mother and daughter母女關係

（D）not related彼此各不相關

28. Which of the following is the most popular theater performance and comedy performance exhibition, and the largest and most famous music festival held during the Edinburgh Music Festival?

下面哪一項是最受歡迎的戲劇表演和喜劇表演展覽，以及在愛丁堡音樂節期間舉辦的最大、最著名的音樂節？

（A）The Proms逍遙音樂會

（B）The Fringe藝穗

（C）The Festival of Lights光明節

（D）The Aldeburgh Festival奧德堡音樂節

29. What is the minimum age for citizens to stand for public office?

公民擔任公職的最低年齡是多少？

（A）16

（B）18

（C）21

（D）25

30. Who was the first Archbishop of Canterbury?

誰是坎特伯雷第一任大主教？

（A）St Augustine聖奧古斯丁

（B）St Columba聖博德同

（C）St Peter聖彼德

（D）Kenneth MacAlpin皮克特國王肯尼思

31. When did the Forced Marriage Protection Order be enacted against England, Wales and Northern Ireland to protect a person from being forced to marry or to protect a person who has been forced to marry?

英國政府何時頒布針對英格蘭、威爾斯和北愛爾蘭的《強迫婚姻保護令》，以保護他人免於被迫結婚或保護已被迫結婚的人？

（A）2007

（B）2008

（C）2010

（D）2011

32. How to call the official reports where the Parliament's proceedings are published?

我們稱英國的「國會議事錄」為：

（A）Domesday Book末日審判書

（B）Hansard英國國會議事錄檔案

（C）Parliamentary reports理事會報告

（D）Carta Magna大憲章

33. **What are the names of the elected members of the Northern Ireland Assembly?**

 北愛爾蘭議會當選議員的名字是什麼？

 （A）MSPs

 （B）MLAs

 （C）MPs

 （D）AMs

34. **What percentage of the total population of the UK is located in Wales?**

 英國的總人口中有多少是位於威爾斯？

 （A）3%百分之三

 （B）5%百分之五

 （C）8%百分之八

 （D）30%百分之三十

35. **What is the capability of the Harrier Jump Jet?**

 獵鷹戰鬥機具備何種能力？

 （A）To carry large amount of passengers可攜帶大量乘客

 （B）Floating on water在水上漂浮

 （C）Vertical takeoff能垂直升降

 （D）Diving可潛水

36. **What is the most famous rugby league (club) game?**

以下哪個是最著名的欖球比賽？

（A）The Grand National英國國家大賽

（B）The All England championship全英冠軍賽

（C）The Six Nations championship六國錦標賽

（D）The Super League欖球超級聯賽

37. **How many people died from the Black Death in England?**

在英格蘭，曾有多少人死於黑死病？

（A）65% of the population人口的百分之六十五

（B）Half of the population人口的一半

（C）One third of the population人口的三分之一

（D）One quarter of the population人口的四分之一

38. **On the British mainland, what is the longest distance is from John O'Groats on the north coast of Scotland to a place in the south-west corner of England?**

在英國大陸上，從蘇格蘭北海岸的約翰·奧格羅特（John O'Groats）到英格蘭西南角的一個地方，距離最長幾多英里？

（A）660

（B）870

（C）980

（D）1080

39. During the Victorian period, which of the following areas did the British Empire NOT cover?

在維多利亞時期，大英帝國沒有覆蓋以下哪個地區？

（A）Mexico墨西哥

（B）Australia澳洲

（C）India印度

（D）Most of Africa非洲大部分地區

40. How long does it take to donate blood?

捐血需要多長時間？

（A）About half an hour約半小時

（B）About an hour約一小時

（C）About two hours約兩小時

（D）About 15 minutes約十五分鐘

41. Which landscape architect designed the ground around the country house to make the landscape look natural, with grass, trees and lakes?

哪位景觀設計師在鄉間別墅周圍設計了地面，使草坪，樹木和湖泊的景觀看起來自然？

（A）Clarice Cliff克拉麗斯·克里夫

（B）Lancelot 'Capability' Brown布朗

（C）Alexander McQueen亞歷山大·麥昆

（D）Vivienne Westwood西太后

42. When was the Northern Ireland Parliament established?

北愛爾蘭議會何時成立？

（A）1922

（B）1932

（C）1925

（D）1928

43. How many Formula One Grand Prix events are held in the UK each year?

英國每年會舉辦幾多場一級方程式大賽？

（A）1

（B）2

（C）3

（D）4

44. What is the capital of Scotland?

蘇格蘭的首都是什麼？

（A）Dundee登地

（B）Aberdeen鴨巴甸

（C）Edinburgh愛丁堡

（D）Glasgow格拉斯哥

45. Who became one of the most popular monarchs in British history, especially after Britain defeated the 'Spanish Armada' in 1588?

誰成為英國歷史上最受歡迎的君主之一，特別是在1588年英國擊敗「西班牙無敵艦隊」之後？

（A）Henry VIII亨利八世

（B）Elizabeth I伊莉莎白一世

（C）James I占士一世

（D）Mary I瑪麗一世

46. When did the Allies defeat Germany at the end of World War II?

第二次世界大戰結束時，盟國何時擊敗德國？

（A）June 1943一九四三年六月

（B）May 1945一九四五年五月

（C）August 1945一九四五年八月

（D）August 1946一九四六年八月

47. What is the name of Sir Francis Drake's ship? It was one of the first ships to travel the world?

法朗西斯·德雷克爵士的船的名字是什麼？哪艘船又是最早環遊世界？

（A）The Golden Eye黃金之眼

（B）The Golden Hind金鹿號

（C）Elizabeth伊莉莎白

（D）The Sharp沙皮

48. Members of the Welsh Assembly are elected every four years on the basis of:

威爾斯議會每四年選議員一次，其依據是：

（A）Proportional representation比例代表

（B）Personal achievements個人成就

（C）All of tabove以上皆是

（D）None of above以上皆否

49. Who was the first British Prime Minister?

誰是英國第一任首相？

（A）Henry Pelham亨利‧佩勒姆

（B）Sir Robert Walpole羅拔‧華爾波爵士

（C）Admiral Nelson尼爾遜海軍上將

（D）Oliver Cromwell奧利華‧克倫威爾

50. Where is Loch Lomond and the Trossachs National Park located?

洛蒙德湖和特羅薩克斯山國家公園在哪裡？

（A）East of Wales威爾斯的東部

（B）West of Wales威爾斯的西部

（C）West of Scotland蘇格蘭的西部

（D）East of Scotland蘇格蘭的東部

51. **After the Black Death, a new social class appeared in England, including the owners of large tracts of land. These people were called:**

 黑死病之後，英格蘭出現了一個新的社會階層，包括大片土地的所有者。這些人被稱為：

 （A）Judiciary司法機構

 （B）Gentry紳士階級

 （C）Slave奴隸

 （D）Nobility貴族

52. **Which court handles the most serious cases of children aged 10 to 17 in England, Wales and Northern Ireland?**

 在英格蘭、威爾斯和北愛爾蘭，哪個法院處理最嚴重的10至17歲兒童案件？

 （A）High Court高等法院

 （B）Youth Court青年法院

 （C）Magistrates' Court治安法院

 （D）Crown Court皇室法院

53. What does the term 'coalition' refer to?

「聯盟」指的是什麼？

（A）If no party wins the majority, a new election will be held and only one of the first two parties will be voted如果沒有任何政黨贏得多數，將舉行新的選舉。只有前兩個政黨中的一個會獲得被選舉的權利。

（B）The candidate with the most votes is elected得票最多的候選人會獲選。

（C）If no party wins the majority, the two parties can participate and govern together 如果任何一方都不能贏得多數席位，則兩黨可以共同參與並共同執政。

（D）If a member of Congress dies or resigns, there will be new elections如果國會議員去世或辭職，將有新的選舉。

54. When did the Rose War begin?

玫瑰戰爭何時開始？

（A）1388

（B）1455

（C）1462

（D）1478

55. **What is the proportion of the British population whose parents or grandparents were born outside the UK after the war?**

戰後父母或祖父母佔在英國以外出生的英國人口幾多個百分比？

（A）Nearly 8% of the population接近百分之八的人口

（B）Nearly 10% of the population接近百分之十的人口

（C）Nearly 12% of the population接近百分之十二的人口

（D）Nearly 20% of the population接近百分之二十的人口

56. **Who is the author of the famous play 'Macbeth'?**

著名戲劇《馬克白》的作者是誰？

（A）Alexander Thomas亞歷山大·托馬斯

（B）William Shakespeare威廉·莎士比亞

（C）Harold Pinter哈羅德

（D）Evelyn Waugh伊夫蓮

57. **Which of the following is NOT a World Heritage Site?**

以下哪個不是世界遺產？

（A）The London Eye倫敦眼

（B）Stonehenge巨石陣

（C）The forts of Housesteads and Vindolanda位於Housesteads和Vindolanda的堡壘

（D）The Houses of Parliament國會大廈

58. Which British writer created the fictional detective Sherlock Holmes?

哪位英國作家創作了虛構的偵探福爾摩斯？

（A）Sir Kingsley Amis金斯利·艾米斯爵士

（B）Robert Louis Stevenson巴爾福·史蒂文森

（C）Sir Arthur Conan Doyle柯南·道爾爵士

（D）Jane Austen珍·奧斯汀

59. What does NATO stand for?

「NATO」代表什麼？

（A）The North American Transparent Organisation北美透明組織

（B）The North Atlantic Trust Organisation北大西洋信託

（C）The North Atlantic Treaty Organisation北大西洋公約組織

（D）The North American Treaty Organisation北美條約組織

60. Who defeated the French at the Battle of Agincourt in 1415?

誰在1415年的「阿金庫爾戰役」中擊敗法國？

（A）King Edward I of England英國國王愛德華一世

（B）William III of England英格蘭威廉三世

（C）Henry VIII亨利八世

（D）King Henry V亨利五世國王

61. Who can ensure that the opposition has enough time to debate the issues chosen in the political debate?

誰能確保反對派有足夠時間來辯論議題？

（A）Shadow Cabinet影子內閣

（B）The Speaker英國國會下議院的議長

（C）The Queen英女王

（D）Nobody沒有人

62. In 2012, to commemorate the 60th anniversary of Queen Elizabeth II's birth, what was the name given to the clock tower of the Parliament?

為紀念伊莉莎白二世女王誕辰60週年，議會的鐘樓在2012年起了什麼名字？

（A）Big Ben大笨鐘

（B）Big Clock大鐘

（C）Elizabeth Tower伊莉莎白塔

（D）Clock Tower鐘塔

63. Which of the following words come from Norman French?

以下哪個單詞是來自諾曼法語？

（A）Apple蘋果

（B）Beauty美女

（C）Cow牛

（D）Summer夏天

64. Who handles cases involving personal injury, family affairs, breach of contract and divorce?

誰負責處理涉及人身傷害、家庭事務、違反合同和離婚的案件？

（A）County Courts縣法院

（B）Sheriff Court郡法院

（C）Crown Court皇室法院

（D）High Court高等法院

65. According to the 2011 census, what percentage of people consider themselves Jewish?

根據2011年人口普查，英國有多少百分比的人自認猶太人？

（A）Less than 0.5%不到0.5%

（B）Less than 1%少於1%

（C）Less than 1.5%低於1.5%

（D）Less than 2%少於2%

66. During this campaign, the Parliament passed laws that gave women the right to equal pay for equal work and made it illegal for employees to discriminate against women because of their sex:

在以下哪項運動中，議會通過了法律賦予婦女同工同酬的權利，並規定僱員因性別而歧視婦女是非法？

（A）The Punk movement龐克運動

（B）The Enlightenment啟蒙運動

（C）The Swinging Sixties搖擺倫敦

（D）The Suffrage投票權運動

67. Under the leadership of Oliver Cromwell, how many years has the UK been a republic?

在奧利弗·克倫威爾（Oliver Cromwell）的領導下，英國成為共和國已有多少年？

(A) 9

(B) 10

(C) 11

(D) 12

68. How many members does the Scottish jury have?

蘇格蘭的法庭陪審團有多少名成員？

(A) 11 十一人

(B) 13 十三人

(C) 15 十五人

(D) 17 十七人

69. When will the election registration be updated?

選舉登記何時更新？

(A) April or May 四月或五月

(B) May or June 五月或六月

(C) September or October 九月或十月

(D) October or November 十月或十一月

70. Where is the Scottish Parliament sitting?

蘇格蘭議會座落哪裡？

（A）Glasgow格拉斯哥

（B）St Andrews聖安德魯斯

（C）Edinburgh愛丁堡

（D）Aberdeen鴨巴甸

71. How many square miles do Loch Lomond and the Trossachs National Park cover?

洛蒙德湖和特羅薩克斯山國家公園佔地幾多平方英里？

（A）720

（B）740

（C）820

（D）840

72. When is New Year's Eve celebrated?

除夕是在什麼時候慶祝？

（A）December 25十二月二十五日

（B）December 30十二月三十日

（C）December 31十二月三十一日

（D）January 1一月一日

73. As part of the naturalization ceremony, to whom must the new citizen swear or confirm loyalty?

作為入籍儀式的一部分，新公民必須向誰發誓或表示忠誠？

（A）The Pope教宗

（B）The Prime Minister首相

（C）The Queen英女王

（D）The Church of England英格蘭教堂

74. Why did Henry VIII marry Anne of Cleves?

亨利八世為何與安妮結婚？

（A）He loves her deeply 他深愛著對方

（B）For political reasons出於政治的考慮

（C）For her fortune為了她的未來

（D）She is having a baby她懷有亨利八世的小孩

75. How is the Speaker elected?

下議院議長是如何選舉出來的？

（A）Secret ballot經由其他成員秘密投票

（B）Proportional representation by members of the House of Lords
由上議院議員的比例代表制選出

（C）Public voting by members of the House of Commons由下議院
議員公開投票

（D）by the Prime Minister由總理選出

Answer:
答案及解析:

1. B

The first people living in the UK were hunter-gatherers, we call it the "Stone Age".
最早在英國居住的人是狩獵採集者,我們稱之為「石器時代」。

2. B

The poetry and drama of Queen Elizabeth's period are rich and diverse, especially the plays and poems of William Shakespeare.
伊莉莎白女王時代的詩歌和戲劇豐富多彩,尤其是莎士比亞的戲劇和詩歌。

3. C

The basic principles of life in the UK include: tolerance of people with different beliefs and beliefs, the rule of law, democracy, personal freedom and participation in community life.
英國的生活基本原則包括:包容具不同信仰和信念的人、法治、民主、個人自由和參與社區生活。

4. B

The cross of St Patrick, the patron saint of Ireland, is a diagonal red cross on a white ground.
愛爾蘭守護聖者聖巴德利爵士(St Patrick)的十字架是在白色背景上的對角紅色交叉。

5. C

Swansea is located in Wales.
史雲斯是位於威爾斯的一個地方。

6. B

December 24th is Christmas Eve.
十二月二十四日是平安夜。

7. D

Sir Steve Redgravewon has rowed at the Olympics for five consecutive times and is one of Britain's greatest Olympians.

史蒂夫·雷德格雷夫爵士已連續五次參加奧運會，並且是英國最偉大的奧運選手之一。

8. A

Sir Tim Berners Lee (1955-), the inventor of the World Wide Web, was British. On December 25, 1990, information was successfully transmitted through the network for the first time.

萬維網發明者蒂姆爵士（Sir Tim Berners Lee），英國人，他在1990年12月25日，首次利用網絡成功傳送信息。

9. D

Today, at Maiden Castle in Dorset, England, you can still see the impressive hill fort from the Iron Age.

今天，在英格蘭多塞特郡的梅登城堡（Maiden Castle）中，您仍然可以看到鐵器時代令人印象深刻的山堡。

10. B

Before the 18th century, agriculture was the largest source of employment in the UK.

在18世紀之前，農業是英國最大的就業來源。

11. B

The Scottish Exhibition and Convention Centre (SECC) is in Glasgow.

蘇格蘭會展中心（SECC）乃蘇格蘭最大的展覽中心場地，位置在格拉斯哥克萊德河（River Clyde）以北。

12. A

The members of the Pre-Raphaelites were an important group of artists in the second half of the 19th century. They painted detailed pictures on religious or literary themes in bright colors. The team members include Holman Hunt, Dante Gabriel Rossetti

and Sir John Millais.

前拉斐爾派（The Pre-Raphaelites，又常被翻譯為「前拉斐爾兄弟會」），其成員是19世紀下半葉的重要藝術家群體。他們以鮮豔的色彩在宗教或文學主題上繪製了詳細的圖畫。團隊成員包括Holman Hunt、Dante Gabriel Rossetti和John Millais爵士。

13. A

The European Union (EU), formerly known as the European Economic Community (EEC), was established by six Western European countries (Belgium, France, Germany, Italy, Luxembourg and the Netherlands), and signed the Treaty of Rome on March 25, 1957.

《羅馬條約》（亦即《建立歐洲經濟共同體條約》）於1958年1月生效，目的是建立歐洲經濟共同體（European Economic Union，即EEC）。該條約於1957年3月25日，由六個歐洲國家（包括法國、盧森堡、比利時、意大利、荷蘭和西德）聯署通過。

14. B

In the years until 1400, Geoffrey Chaucer wrote a series of poems in English about a group of people on a pilgrimage to Canterbury. People decided to tell stories to each other during the journey. This poem describes the travellers and some of their stories. This collection of poems is called "The Canterbury Tales".

直到1400年，傑弗里·喬叟（Geoffrey Chaucer）用英語寫了一系列詩歌，講述一群人朝坎特伯雷（Canterbury）朝聖。人們決定在旅途中互相講故事。這首詩描述了旅行者和他們的一些故事。這首詩集被稱為《坎特伯雷故事集》。

15. C

Poems that survived the Middle Ages include Joe Cuc's "Canterbury Tales" and a poem called Sir Gawain and the Knight of Green, about a knight in the Arthurian court.

在中世紀倖存下來的詩歌包括Joe Cuc的《坎特伯雷故事》（Canterbury Tales）和一首名叫加文爵士（Sir Gawain）和格林騎士（Knight of Green）的詩歌，講述的是亞瑟王朝的一個騎士。

16. C

Mary Stuart, Queen of Scots (commonly now known as "Mary of Scots") is a Catholic. Her father died and became queen only one week old.

蘇格蘭女王瑪麗・斯圖加特（Mary Stuart）（通常現在稱為「蘇格蘭瑪麗」）是一名天主教徒。她的父親去世，僅一個星期大就成為女王。

17. D

During World War II, British films (such as "We Serve in It") played an important role in raising morale.

在第二次世界大戰期間，英國電影《In Which We Serve》（與祖國同在），在提升士氣方面，發揮了重要作用。

18. D

Elected members of the Welsh Assembly meet in the Seneddin Cardiff Bay.

The elected members of the Welsh Assembly meet in Cardiff Bay, Seneddin.

威爾斯議會當選議員在塞尼丁卡迪夫灣（Cardiff Bay）開會。

19. C

During the Victorian period, the British Empire gradually expanded to the whole of India, Australia and most of Africa. It became the largest empire in the history of the world, with an estimated population of over 400 million.

在維多利亞時期，大英帝國逐漸擴展到整個印度，澳洲和非洲大部分地區。它成為世界歷史上最大的帝國，估計人口超過4億。

20. C

Mrs. Kelly Holmes (Dame Kelly Holmes) won two gold medals at the 2004 Olympics. She has many British and European records.

Dame Kelly Holmes在2004年奧運會上獲得了兩枚賽跑金牌。她還擁有許多英國和歐洲的殊榮。

21. D

Radioactivity is not a British invention.

放射性（Radioactivity）不是英國的發明。

22. B

Thistle is a flower associated with Scotland.

薊花是與蘇格蘭相關的花。

23. B

The basic principles of British life include: democracy, rule of law, personal freedom, tolerance for people of different beliefs and beliefs, and participation in community life.

英國生活的基本原則包括：民主、法治、人身自由、對不同信仰和信仰的人的包容以及對社區生活的參與。

24. B

Anniversary service is the focus of anniversary service, located in Whitehall, London.

週年紀念服務位於英國倫敦白廳。

25. B

Welsh cake is a traditional Welsh snack made from flour, dried fruits and spices. It can be eaten hot or cold.

威爾斯鬆餅（Welsh　cake）是由麵粉、乾果和香料製成的傳統威爾斯小食，可冷熱食用。

26. B

Mousetrap is a murder mystery drama by Dame Agatha Christie. It has been screened in the West End since 1952, and it is the longest performance ever.

《捕鼠器》是Dame Agatha Christie的謀殺神秘劇。自1952年以來就在倫敦西區劇院放映，這是有史以來最長的演出。

27. A

Mary, Queen of Scots is the cousin of Elizabeth I.

瑪麗一世跟伊莉莎白一世是表親關係。

28. B

The Fringe will mainly show drama and comedy performances. It often shows experimental works. The largest and most famous is the Edinburgh Music Festival Fringe.

The Fringe主要表演戲劇和喜劇表演。它經常顯示實驗創作。最大和最著名的是「愛丁堡國際藝穗節」。

29. B

Most citizens of the United Kingdom, the Republic of Ireland or the Commonwealth, who are 18 years of age or older, can hold public office.

英國、愛爾蘭共和國,以及英聯邦王國的大多數公民,凡年齡在18歲以上,均可擔任公職。

30. A

Saint Augustine became the first Archbishop of Canterbury.

聖奧古斯丁成為坎特伯雷第一任大主教。

31. B

According to the Forced Marriage (Civil Protection) Act 2007, England, Wales and Northern Ireland introduced the Forced Marriage Protection Order in 2008.

根據《2007年強迫婚姻(民事保護)法》,英格蘭、威爾斯和北愛爾蘭於2008年制定了《強迫婚姻保護令》。

32. B

The proceedings of the Congress are broadcast on television and published in an official report called the "Procedures".

國會的議事錄在電視上播出,並發表在稱為《英國國會議事錄檔案》(Hansard)的正式報告。該份文件是由Hansard Department(議事錄編製部)製作。

33. B

Members of the Northern Ireland Parliament are called Mutual Legal Assistance (Members of the Legislative Assembly).

北愛爾蘭議會的成員稱為MLAs(即Members of the Legislative Assembly)。

34. B

The total population of the United Kingdom in Wales is about 5%.

英國在威爾斯的總人口約為5%。

35. C

The Harrier Jump Jet is an aircraft that can take off vertically and was also designed and developed in the UK.

獵鷹戰鬥機（Harrier Jump Jet）是一種可以垂直起飛的飛機，也是在英國設計和開發的。

36. D

The Super League is the most famous rugby league (club) competition.

欖球超級聯賽（The Super League）是最著名的欖球聯賽比賽。

37. C

As a result of the Black Death, one-third of the population in England died, and the proportions in Scotland and Wales were similar.

黑死病的結果是，英格蘭三分之一的人口死亡，蘇格蘭和威爾斯的比例相似。

38. B

The longest distance on the mainland is from John O'Groats on the north coast of Scotland to Land's Endin in the southwest corner of England. This is about 870 miles (about 1,400 kilometers).

最長的距離是從蘇格蘭北海岸的John O'Groats到英格蘭西南角的Endin。這是大約870英里（約1,400公里）。

39. A

During the Victorian period, the British Empire gradually expanded to India, Australia and most of Africa.

在維多利亞時期，大英帝國逐漸擴展到印度、澳洲和非洲大部分地區。

40. B

It only takes about an hour to donate blood.

捐血僅需要一小時。

41. B

In the 18th century, Lancelot's "ability" Brown designed the ground around the country house to make the landscape look natural, with grass, trees and lakes. He often collaborates with Edwin Lutyens to design colorful gardens around the houses he designs.

在18世紀，Lancelot 'Capability' Brown設計了鄉村別墅周圍的地面，使草地、樹木和湖泊的景觀顯得自然。他經常與Edwin Lutyens合作，在他設計的房屋周圍設計色彩繽紛的花園。

42. A

The Northern Ireland Parliament was established in 1922.

北愛爾蘭議會於1922年愛爾蘭分裂時成立，但該議會於1972年被廢除。

43. A

The Formula One Grand Prix event is held in the UK every year, and many British Grand Prix drivers have won the Formula One World Championship.

一級方程式大獎賽賽事每年都會在英國舉行一次，許多英國大獎賽車手都贏得了一級方程式世界錦標賽。

44. C

The capital of Scotland is Edinburgh.

蘇格蘭的首都是愛丁堡。

45. B

Elizabeth I became one of the most popular monarchs in British history, especially after the British defeated Spain in 1588 to conquer England and restore the Catholic Spanish Fleet (a large fleet).

伊莉莎白一世成為英國歷史上最受歡迎的君主之一，尤其是在英國於1588年擊敗有「西班牙無敵艦隊」之稱的西班牙海軍後。

46. B

After winning on the beaches of Normandy, the Allied forces continued through France and eventually entered Germany. In May 1945, the Allied forces completely defeated Germany.

在諾曼第一役獲勝後，盟軍繼續穿越法國，最終進入德國。1945年5月，盟軍徹底擊敗了德國。

47. B

Sir Francis Drake was one of the commanders who defeated the Spanish fleet and one of the founders of the English naval tradition. His ship Golden Hind was one of the first people to travel the world.

法朗西斯·德雷克爵士是擊敗西班牙艦隊的指揮官之一，也是英國海軍傳統的奠基人之一。他的船Golden Hind是最早環遊世界的人之一。

48. A

The National Assembly of Wales has 60 members (AM), and elections are held every four years, using a proportional representation system.

威爾斯國民議會有60名議員，選舉每四年舉行一次，並採用比例代表制選出議員。

49. B

The first person of the British Prime Minister was Sir Robert Walpole, who was the Prime Minister from 1721 to 1742.

英國首相的第一人是羅伯特·沃爾波勒爵士，任期由1721至1742年。

50. C

Loch Lomond and the Trossachs National Park is located in the west of Scotland.

全英國境內最大的湖洛蒙德湖（Loch Lomond）和蘇格蘭國家公園「特羅薩克斯山國家公園」（Trossachs National Park）位於西蘇格蘭。

51. B

After the outbreak of the Black Death, the decline in population meant that the demand for growing cereal crops decreased. With labor shortages, farmers began to demand higher wages. A new social class emerged, including owners of large tracts of land (later called gentlemen), and people left the countryside to live in towns. In cities and towns, the growth of wealth has led to the development of a powerful middle class.

黑死病爆發後，人口減少意味著對穀物作物的需求下降。由於勞動力短缺，農民開始要求更高的工資。出現了新的社會階級，包括大片土地的所有者（後稱紳士），人們離開了鄉村居住在城鎮中。在城鎮，財富的增長導致了強大的中產階級的發展。

52. D

In England, Wales and Northern Ireland, if the defendant is between 10 and 17 years old, the case is usually heard in a youth court before up to three specially trained magistrates or magistrates. The most serious cases will be heard by the Supreme Court.

在英格蘭、威爾斯和北愛爾蘭，如果被告年齡在10到17歲之間，通常會在最多三名經過特別培訓的地方法官之前在青年法院（Youth Court）審理此案。最嚴重的案件將由皇室法院（Crown Court）審理。

53. C

The government usually consists of the party that wins the majority of the electoral districts. If no party wins a majority, the two parties can form a coalition together.

政府通常由贏得多數選舉區的政黨組成。如果沒有任何一方贏得多數，則兩黨可以組成一個聯盟。

54. B

In 1455, a civil war began to decide who should become the king of England. It was carried out between supporters of two families: Lancaster Palace and York Palace. This war is called the "War of the Roses" because the symbol of Lancaster is a red rose and the symbol of York is a white rose.

1455年，一場內戰開始決定誰應該成為英格蘭國王。它是在兩個家庭的支持者之間進行的：the House of Lancaster 和the House of York。這場戰爭被稱為「玫瑰戰爭」，因為Lancaster的象徵是一朵紅玫瑰，York的象徵是一朵白玫瑰。

55. B

Post-war immigration meant that nearly 10% of the population's parents or grand-parents were born outside the UK.

戰後移民意味著約有10％的父母或祖父母在英國以外出生。

56. B

Macbeth is a famous play by William Shakespeare.

《馬克白》是莎士比亞的著名戲劇。

57. A

The London Eye is not a World Heritage Site.

倫敦眼不是世界遺產。

58. C

Sir Arthur Conan Doyle is a Scottish doctor and writer. He is famous for the story about Sherlock Holmes, one of the earliest novel detectives.

亞瑟·柯南·道爾爵士是蘇格蘭的醫生和作家。他以有關最早的小說偵探之一：「福爾摩斯」的故事而聞名。

59. C

NATO stands for North Atlantic Treaty Organization.

NATO（The North Atlantic Treaty Organisation）代表「北大西洋公約組織」。

60. D

One of the most famous battles in the Hundred Years' War was the Battle of Agincourt in 1415, in which King Henry V's large British army defeated the French.

百年戰爭中最著名的戰役之一是1415年的阿金庫爾戰役，其中亨利五世國王的龐大英軍擊敗了法國人。

61. B

The Speaker maintains order in the political debate to ensure compliance with the rules. This includes ensuring that the opposition has enough time to debate issues of their choice.

下議院議長（Speaker of the House of Commons，簡稱The Speaker）是英國國會下議院的議長。他在政治辯論中維持秩序，以確保遵守規則。這包括確保反對派有足夠的時間辯論他們選擇的問題。

62. C

The clock tower of the House of Representatives in London was named "Elizabeth Tower" to commemorate the 2012 Diamond Jubilee of Queen Elizabeth II.

倫敦眾議院的鐘樓被命名為「伊莉莎白塔」，以紀念2012年伊莉莎白二世女王鑽禧。

63. B

Certain words in modern English (such as "park" and "beauty") are based on Norman French words.

現代英語中某些單詞（如 park和 beauty）是由諾曼法語單詞演化出來。

64. B

The County Courts handles various civil disputes. These include people trying to get back money owed to them, cases involving personal injury, family affairs, breach of contract and divorce. In Scotland, the Sheriff Court will deal with most of these issues.

縣法院（County Courts）處理各種民事糾紛。這些包括試圖取回欠他們的錢的人、涉及人身傷害、家庭事務、違反合同和離婚的案件。在蘇格蘭，地方法院將處理大多數此類問題。

65. A

According to the 2011 census, less than 0.5% of people consider themselves Jewish.

根據2011年進行的人口普查，不到0.5％的人認為自己是猶太人。

66. C

The Swinging Sixties was a period when parliament passed a new law to give women the right to equal wages, and it was illegal for employers to discriminate against women on the basis of sex.

1960年代動盪不定的時期，議會通過了一項新法律，賦予婦女同等工資的權利，雇主以性別歧視婦女是非法的。

67. C

Britain is a republic under the leadership of Oliver Cromwell and has a history of 11 years.

英國曾是奧利弗·克倫威爾（Oliver Cromwell）領導下的共和國，擁有11年的歷史。

68. C

In England, Wales and Northern Ireland, the jury has 12 members, and in Scotland, the jury has 15 members.

在英格蘭、威爾斯和北愛爾蘭，陪審團有12名成員。在蘇格蘭，陪審團有15名成員。

69. C

The electoral register is updated every September or October.

選舉登記冊每年九月或十月更新。

70. C

In Scotland, the elected MPs are called MSPs and meet at the Scottish Parliament Building in Holyrood, Edinburgh.

在蘇格蘭，當選的國會議員被稱為MSP，並在愛丁堡荷里路德的蘇格蘭議會大廈會晤。

71. A

Loch Lomond and Trossachs National Park cover 720 square miles (1,865 square kilometers) in western Scotland.

洛蒙德湖和特羅薩克斯山國家公園在蘇格蘭西部佔地720平方英里（1,865平方公里）。

72. C

Celebrate New Year's Eve on December 31.

12月31日慶祝除夕。

73. C

As part of the citizenship ceremony, new citizens swear or affirm their loyalty to the Queen.

作為入籍儀式的一部分，新公民發誓或確認對女王的忠誠。

74. A

Henry married Anne of Clives for political reasons, but divorced her soon after.

亨利出於政治原因與安妮結婚，但不久二人就離婚了。

75. A

The Speakers are elected by other members of Congress by secret ballot.

下議院議長由其他國會議員以無記名投票方式選出。

2.2

正誤題
Decide Whether A Statement Is True Or False

1. The Commonwealth has no rights to its members and cannot suspend its membership.

 英聯邦對其成員沒有實權，也無法取消成員的資格。

 （A）True 正確

 （B）False 錯誤

2. Black Death only affected children and the elderly.

 黑死病僅影響兒童和老人。

 （A）True 正確

 （B）False 錯誤

3. The public can listen to the debates at the Palace of Westminster in the public galleries of the House of Commons and the House of Lords.

 公眾可以在下議院和上議院公共畫廊的西敏宮旁聽辯論。

 （A）True 正確

 （B）False 錯誤

4. Table foorball game (a traditional pub games) originates from Britain .

 足球機（一種傳統的酒吧遊戲）是由英國人發明。

 （A）True 正確

 （B）False 錯誤

5. Britain is a "constitutional monarchy" country.

 英國是行使「君主立憲」制度的國家。

 （A）True 正確

 （B）False 錯誤

6. Forcing others to marry is not punished in Britain.

 強迫他人結婚不是刑事罪行。

 （A）True 正確

 （B）False 錯誤

7. A good way to support the local community is to buy products locally.

 支持本地社區的一個好方法是在本地購買產品。

 （A）True 正確

 （B）False 錯誤

8. English has many accents and dialects.

 英語有很多口音和方言。

 （A）True 正確

 （B）False 錯誤

9. **If people owe someone money, they may be sued.**

 如果人們欠某人錢，他們可能會被起訴。

 （A）True 正確
 （B）False 錯誤

10. **The Welsh dragon on the Welsh flag did not appear on the United Nations flag because when the first United Nations flag was created by the flags of Scotland and England in 1606, the Principality of Wales had been unbound from England.**

 威爾斯國旗上的威爾斯巨龍沒有出現在聯合國國旗上，因為當1606年蘇格蘭和英格蘭的國旗創造了第一支聯合國國旗時，威爾斯公國不受英國的約束。

 （A）True 正確
 （B）False 錯誤

11. **Sir Alfred Hitchcock is an important English film director.**

 希區柯克爵士是英國電影史上的著名導演。

 （A）True 正確
 （B）False 錯誤

12. **The proceedings of the Parliament are not broadcast on TV, but published in the official report.**

 英國國會的議事程序不會在電視上播放，而是在官方報告中發布。

 （A）True 正確
 （B）False 錯誤

13. In Northern Ireland, a newly qualified driver must display an R plate for TWO years after passing the test.

 在北愛爾蘭，新牌司機必須在通過考試後展示「P卡」兩年。

 （A）True 正確
 （B）False 錯誤

14. The public can listen to the debate at the Houses of Parliament in the public gallery of the House of Commons, but not in the House of Lords.

 公眾可以在下議院公共畫廊的國會大樓旁聽辯論，但在上議院則不能。

 （A）True 正確
 （B）False 錯誤

15. Sir Winston Churchill was the son of a musician.

 邱吉爾是一位音樂家的兒子。

 （A）True 正確
 （B）False 錯誤

16. For some Scots, the Hogmanay holiday is much bigger than Christmas.

 對於某些蘇格蘭人來說，霍格莫內的假期比聖誕節重要得多。

 （A）True 正確
 （B）False 錯誤

17. Prince Charles is also known as the Prince of Edinburgh.

查理斯王子也被稱為愛丁堡王子。

（A）True 正確

（B）False 錯誤

18. Slaves were brought from West Asia to the Britain during the 'Slave Trade' to cultivate tobacco and sugar plantations.

在奴隸貿易期間，奴隸從亞洲被帶到英國種植煙草和蔗糖。

（A）True 正確

（B）False 錯誤

19. Members of the Welsh Assembly can speak both English and Welsh, but all publications of the conference must be in English.

威爾斯議會的議員可以說英語和威爾斯語，但會議的所有出版物必須使用英文。

（A）True 正確

（B）False 錯誤

20. House of Lords members may stand for election to the House of Commons and are eligible for all public offices.

英國上議院的議員可以競選下議院議員，並有資格擔任所有公共職務。

（A）True 正確

（B）False 錯誤

21. The police force is a public service, aims at helping and protecting everyone.

　　警察部隊是一種公共服務，可以幫助並保護所有人。

　　（A）True 正確

　　（B）False 錯誤

22. In Scotland, Gaelic is spoken in some areas of the Highlands and Islands.

　　在蘇格蘭，蓋爾語在高地和群島的某些地區講。

　　（A）True 正確

　　（B）False 錯誤

23. Participation in community life is a basic principle of British life.

　　參與社區生活是英國人生活的基本原則。

　　（A）True 正確

　　（B）False 錯誤

24. The decade of the 1960s was a period of major social change, when British fashion, film and popular music grew.

　　1960年代是一個重大的社會變革時期，當時英國的時裝，電影和流行音樂日漸盛行。

　　（A）True 正確

　　（B）False 錯誤

25. If you watch TV without a TV license, you will be fined up to £ 2,000.

如果您沒有電視許可證就看電視，將被處以最高2,000英鎊的罰款。

（A）True 正確

（B）False 錯誤

26. In 1885, Emmeline Pankhurst founded the Women's Franchise League, which worked hard to win votes in local elections for married women.

艾米琳‧潘克斯特（Emmeline Pankhurst）於1885年成立「婦女投票權同盟」（Women's Franchise League），努力在已婚婦女的地方選舉中贏得選票。

（A）True 正確

（B）False 錯誤

27. The Queen is the head of state of the United Kingdom.

英女王是英國國家元首。

（A）True 正確

（B）False 錯誤

28. The Welsh Assembly has 129 Assembly members and the Scottish Parliament has 60 members.

威爾斯議會有129名成員，蘇格蘭議會有60名成員。

（A）True 正確

（B）False 錯誤

29. Since the death of his father King George V in 1952, the queen has been in power. In 2012, the Queen celebrated her Diamond Jubilee.

自1952年父親喬治五世逝世以來，英女王一直掌權。2012年，女王慶祝自己的鑽禧紀念。

（A）True 正確

（B）False 錯誤

30. A woman who violently treat her partners will not be punished in the UK.

暴力對待伴侶的婦女在英國不能受到起訴。

（A）True 正確

（B）False 錯誤

31. In 1837, Queen Victoria became the queen of the UK at the age of 20.

1837年，維多利亞女王以20歲之齡，成為英格蘭女王。

（A）True 正確

（B）False 錯誤

32. The UK continues to maintain a world-leading position in the development and manufacturing of motorsport technology.

英國在賽車技術的開發和製造方面繼續保持世界領先地位。

（A）True 正確

（B）False 錯誤

33. In Northern Ireland, some TV programs are broadcast in Gaelic, Ireland.

在北愛爾蘭，一些電視節目會以蓋爾語播出。

（A）True 正確

（B）False 錯誤

34. Great Britain only refers to England, Scotland, Wales and Northern Ireland.

英國是指英格蘭、蘇格蘭、威爾斯和北愛爾蘭。

（A）True 正確

（B）False 錯誤

35. Wales and Northern Ireland have their own banknotes, which are valid throughout the UK. However, shops and businesses do not have to accept them.

威爾斯和北愛爾蘭擁有自己的鈔票，在整個英國都有效，但商店和企業不必接受它們。

（A）True 正確

（B）False 錯誤

36. Liechtenstein citizens can drive in the UK as long as their driving license is valid.

列支敦士登公民只要其駕駛執照有效，就可以在英國境內駕駛。

（A）True 正確

（B）False 錯誤

37. Catherine Parr, the sixth wife of Henry VIII, was a cousin of Anne Boleyn.

 亨利八世的第六任妻子凱瑟琳·帕爾是安妮·波林的表親。

 （A）True 正確

 （B）False 錯誤

38. Hanukkah is a Jewish festival to commemorate the Jewish struggle for religious freedom.

 光明節是猶太人的節日，以紀念猶太人爭取宗教自由的鬥爭。

 （A）True 正確

 （B）False 錯誤

39. Taking care of yourself and your family is one of the duties of British permanent residents or citizens.

 照顧好自己和家人是英國永久居民或公民的職責之一。

 （A）True 正確

 （B）False 錯誤

40. Forced marriage refers to a situation where one or both parties disagree or cannot agree to establish a partnership.

 強迫婚姻是指一方或雙方不同意或不同意建立伴侶關係的情況。

 （A）True 正確

 （B）False 錯誤

41. Northern Ireland and Scotland have their own banknotes. These banknotes are valid throughout the UK. Shops and businesses are obliged to accept them.

北愛爾蘭和蘇格蘭都有自己的鈔票。這些鈔票在整個英國都有效。商店和企業有義務接受它們。

（A）True 正確

（B）False 錯誤

42. Throughout the 1990s, after the 1990 invasion of Iraq and the conflict in the former Yugoslav Republic, the United Kingdom played a leading role in the coalition forces involved in the liberation of Kuwait.

在整個1990年代，在1990年伊拉克入侵和前南斯拉夫共和國的衝突之後，聯合王國在參與解放科威特的聯軍中起著領導作用。

（A）True 正確

（B）False 錯誤

43. The Isle of Man is a Crown dependency.

曼島是英國皇家屬地之一。

（A）True 正確

（B）False 錯誤

44. The Commonwealth is based on the core values of democracy, good governance and the rule of law.

英聯邦是建基於民主、善政和法治的核心價值觀。

（A）True 正確

（B）False 錯誤

45. During Margaret Thatcher's administration, the privatization of nationalized industries made structural adjustments to the economy and exercised legal control of trade union power.

在戴卓爾夫人執政期間，國有工業的私有化對經濟進行了結構調整，並對工會權力實行了法律控制。

（A）True 正確

（B）False 錯誤

46. After the outbreak of the Black Death, the growing wealth in towns led to the development of a powerful middle class.

黑死病爆發後，城鎮中日益增長的財富導致了強大的中產階級的發展。

（A）True 正確

（B）False 錯誤

47. In the UK, a National Lottery is drawn every day.

在英國，每天都會抽籤一張國家彩票。

（A）True 正確

（B）False 錯誤

48. In Wales, the jury has to listen to the evidence presented at the trial and then decide a verdict of 'guilty', 'not guilty' or 'not proven' based of what they have heard.

在威爾斯，陪審團必須聽取審判中提供的證據，然後根據他們所聽到的來決定「有罪」、「無罪」或「無證」的裁決。

（A）True 正確
（B）False 錯誤

49. The National Insurance Number can prove to your employer that you have the right to work in the UK.

國家保險號碼可以向您的僱主證明您有權在英國工作。

（A）True 正確
（B）False 錯誤

50. The United Kingdom is one of the five permanent members of the United Nations Security Council.

英國是聯合國安全理事會五個常任理事國之一。

（A）True 正確
（B）False 錯誤

51. The Youth Court does not allow members of the public, and the names or photos of the young defendants cannot be published in newspapers or used by the media.

青年法院不允許公眾開放，年輕被告的姓名或照片不能在報紙上發布或被媒體使用。

（A）True 正確
（B）False 錯誤

52. To apply to become a permanent resident or citizen of the UK, you need to have a university degree.

要申請成為英國永久居民或公民，您需要擁有大學學位。

（A）True 正確

（B）False 錯誤

53. Cruel treatment or neglect of pets is illegal.

殘忍對待或疏忽照顧寵物屬非法行為。

（A）True 正確

（B）False 錯誤

54. Drinking alcohol in public places may constitute a criminal offence, and you may be fined or arrested for.

在公共場所喝酒而可能構成刑事犯罪，您可能因而被警察罰款或逮捕。

（A）True 正確

（B）False 錯誤

55. Mary I (the Queen of Scotland) was a Protestant.

蘇格蘭女王瑪麗一世是位新教徒。

（A）True 正確

（B）False 錯誤

56. On Remembrance Day (Nov 11), there is a two-minute silence at 11pm to commemorate those who died in World War I.

在國殤紀念日，英國政府為紀念第一次世界大戰中的遇難者，會於上午11時進行長達2分鐘的默哀儀式。

（A）True 正確

（B）False 錯誤

57. In England, Northern Ireland and Wales, if the defendant is over 18, the case will be heard in the Youth Court.

在英格蘭、北愛爾蘭和威爾士，假如被告年滿18歲，將在青年法院審理此案。

（A）True 正確

（B）False 錯誤

58. Royal Ascot is a 4-day horse race meeting in Berkshire, which is attended by members of the Royal Family.

雅士谷賽馬日是在伯克郡舉行的為期四天賽馬活動，該項活動是由王室成員參加。

（A）True 正確

（B）False 錯誤

59. In Scotland, all programmes are broadcasted in English.

在蘇格蘭，所有電視節目均以英語播出。

（A）True 正確

（B）False 錯誤

60. The UN was set up after the First World War with the purpose of preventing war and promoting international peace and security.

聯合國在第一次世界大戰後成立，旨在防止戰爭並促進國際和平與安全。

（A）True 正確
（B）False 錯誤

61. The Conservative and the Liberal Democrat Parties formed an coalition in May 2010, and the Liberal Democratic Party leader David Cameron became Prime Minister.

2010年5月，保守黨與自由民主黨組成聯合政府，自由民主黨領袖卡梅倫成為總理。

（A）True 正確
（B）False 錯誤

62. The act of harassing, frightening or distressing someone because of their religion or ethnic origin is a civil offence.

因某人的宗教或種族出身而騷擾，恐嚇或困擾他的行為是民事犯罪。

（A）True 正確
（B）False 錯誤

63. In Britain, many people continue to spend their holidays and leisure activities in the countryside, such as walking, camping and fishing.

在英國，許多人繼續在鄉村度過假期和休閒活動，例如散步、露營和釣魚。

（A）True 正確

（B）False 錯誤

64. Britain's Queen Elizabeth era was a period of growing patriotism: the British were proud that British explorers sought new trade routes and tried to expand British trade to the Spanish colonies in the Americas.

英國伊莉莎白女王時代是愛國主義日益濃厚的時期：英國人為英國探險家尋求新的貿易路線，並試圖將英國貿易擴展到美洲的西班牙殖民地感到自豪。

（A）True 正確

（B）False 錯誤

65. The House of Commons is usually more independent of the government than the House of Lords.

下議院通常比上議院更獨立於政府。

（A）True 正確

（B）False 錯誤

66. In Wales, a lot of people speak Gaelic - a completely different language from English which is taught in schools and universities.

在威爾斯，許多人說蓋爾語，這是一種與英語完全不同的語言，並會在大學和學校中講授。

（A）True 正確

（B）False 錯誤

67. Each member of parliament represents a parliamentary electoral district, which is a small area of the country.

每個國會議員代表一個國會選區，國會選區是一處小區域。

（A）True 正確

（B）False 錯誤

Answer:
答案及解析：

1. B

The Commonwealth can suspend membership.

英聯邦可以中止其成員的資格。

2. B

In 1348, a disease spread to England. This is the so-called Black Death. One-third of the population in England die, and the proportions of the population in Scotland and Wales are comparable. This is one of the worst disasters ever hitting Britain. After the outbreak of the Black Death, the smaller population meant that the demand for growing cereal crops decreased. With labor shortages, farmers began to demand higher wages.

1348年，黑死病傳到了英格蘭，令英格蘭有三分之一的人口死亡，蘇格蘭和威爾斯的人口比例是可比的。這是英國有史以來最嚴重的災難之一。黑死病爆發後，人口減少意味著對穀物作物的需求下降。由於勞動力短缺，農民開始要求更高的工資。

3. A

The House of Parliament is also known as the Palace of Westminster．

國會大廈又稱為西敏宮。

4. B

足球機的發明者不詳。

Nobody is sure who invented it

5. A

6. B

Forcing others to marry is a crime.

強迫他人結婚是犯罪。

7. A

8. A

9. A

10. A

11. A

Eminent directors included Sir Alexander Korda and Sir Alfred Hitchcock, who later left for Hollywood and remained an important film director until his death in 1980.

Famous directors include Sir Alexander Kodak and Sir Alfred Hitchcock, who later went to Hollywood and served as important film directors until their death in 1980.

著名導演包括亞歷山大·柯達爵士和阿爾弗雷德·希區柯克爵士，他們後來去荷里活擔任重要的電影導演，直到1980年去世。

12. B

The proceedings of the Parliament are broadcast on television and published in an official report called the "Hansard".

國會的議事錄在電視上播出，並發表名為「議事錄」（Hansard）的官方報告。

13. B

In Northern Ireland, newly qualified drivers must show the 'R' plate for one year after passing the test.

在北愛爾蘭，新牌司機必須在通過考試後出示「R」卡（R代表Restricted）一年

14. B

The public can listen to the debates at the Houses of Parliament in the public galleries
of the House of Commons and the House of Lords.

公眾可以在下議院和上議院公眾畫廊的國會大樓旁聽辯論。

15. B

Churchill is the son of a politician. His father Abba Lord Randolph Churchill was the
British Minister of Financee.

邱吉爾是一位政治家的兒子，其父Lord　Randolph　Churchill曾擔任財務大臣一
職。

16. A

In Scotland, December 31 is called Hogmanay, and January 2 is also a public holiday.
For some Scots, the Hoge Manet holiday is bigger than the Christmas holiday.

在蘇格蘭，12月31日被稱為「霍格莫內」(Hogmanay)，1月2日也是公眾假期。
對於某些蘇格蘭人而言，霍格莫內假期比聖誕節更重要。

17. B

Prince Charles is also known as the Prince of Wales.

查理斯王子也被稱為威爾斯親王。

18. B

Slaves were brought from West Africa to the United States and the Caribbean during
the 'Slave Trade' to cultivate tobacco and sugar plantations.

在奴隸貿易期間，奴隸從西非被帶到美國和加勒比海種植煙草和蔗糖。

19. B

Members of the Welsh Assembly can speak English and Welsh, and all conference
publications are written in both languages.

威爾斯議會議員會講英語和威爾斯語，所有會議出版物均以兩種語言編寫。

20. B

Members of the House of Lords are not allowed to participate in the election of the House of Commons, but are eligible to hold all other public offices.

上議院的議員不得參加下議院選舉,但有資格擔任其他所有公職。

21. A

The police force is a public service that can help and protect everyone, regardless of their background or place of residence.

警察部隊是一項公共服務,可以幫助和保護所有人,無論他們的背景或居住地如何。

22. A

In Scotland, Gaelic is spoken in certain parts of the Highlands and Islands, while in Northern Ireland, Irish Gaelic is spoken.

在蘇格蘭,高地和群島的某些地區會說蓋爾語,而在北愛爾蘭,會說愛爾蘭蓋爾語。

23. A

The basic principles of life in the UK include: participation in community life.

英國的生活基本原則包括:參與社區生活。

24. A

The 1960s was the golden age of Britain, known as "the Swinging Sixties" (the Swinging Sixties).

六十年代,是英國的黃金時代,號稱「the Swinging Sixties」(搖擺的六十年代)。

25. B

If you watch TV without a TV license, you will be fined up to £1,000.

如果您沒有電視許可證就看電視,將被處以最高1,000英鎊的罰款。

26. B

Emmeline Pankhurst was born in Manchester in 1858. She founded the Women's Franchise League in 1889, which worked hard to win votes in local elections for married women.

艾米琳·潘克赫斯特（Emmeline Pankhurst）於1858年生於曼徹斯特。她在1889年成立「婦女投票權同盟」，同盟努力在已婚婦女的地方選舉中贏得選票。

27. A

Queen Elizabeth II is the head of state of the United Kingdom.

伊麗莎白女王二世是英國的元首。

28. B

The Welsh assembly has 60 Assembly members and the Scottish Parliament has 129 members.

威爾斯議會有60名成員，蘇格蘭議會有129名成員。

29. B

Queen's father is King George VI.

英女王的父親是英王喬治六世。

30. B

Anyone who actss violently towards his or her partner – whether he or sheis a man or a woman, married or living together– can be prosecuted.

任何對伴侶採取暴力行動的人，無論是男是女、已婚或同居，均會被起訴。

31. B

In 1837, Queen Victoria became Queen of England at the age of 18.

1837年，維多利亞女王在18歲時成為英格蘭女王。

32. A

In the UK, motorsports for cars and motorcycles have a long history. British motorsport started in 1902. The UK continues to maintain its leading position in the world in developing and manufacturing racing technology.

在英國，汽車和摩托車的賽車運動歷史悠久。英國賽車運動始於1902年。英國在開發和製造賽車技術方面繼續保持世界領先地位。

33. A

There are some programs specific to Northern Ireland, and some TV programs are broadcast in Irish Gaelic.

有一些特定於北愛爾蘭的節目，有些電視節目在愛爾蘭蓋爾語中播放。

34. B

Great Britain refers only to England, Scotland and Wales, not Northern Ireland

英國僅指英格蘭、蘇格蘭和威爾斯，不指北愛爾蘭。

35. B

Northern Ireland and Scotland have their own banknotes, which are valid anywhere in the UK. However, shops and businesses do not have to accept them.

北愛爾蘭和蘇格蘭都有自己的鈔票，這些鈔票在英國任何地方都有效。但是，商店和企業不必接受它們。

36. A

If your driving license is from a country in the European Union (Iceland), Iceland, Liechtenstein or Norway, you can drive in the UK as long as your license is valid.

如果您的駕駛執照來自歐盟（冰島）、冰島、列支敦士登或挪威的國家/地區，則只要您的駕照有效，就可以在英國駕駛。

37. B

Catherine Howard is cousin of Anne Boleyn.

凱瑟琳 霍華德是安妮 伯林（Anne Boleyn）的表弟。

38. A

Hanukkah is celebrated for eight days in November or December. The festival is to remember the struggle of the Jews for religious freedom.

為期8天的光明節在11月或12月舉行，該節日是用以紀念猶太人爭取宗教自由的鬥爭。

39. A

40. A

Forced marriage refers to a situation in which one or both parties disagree or cannot express their consent to a partnership.

強迫婚姻是指一方或雙方不同意或無法表示同意伴侶關係的情況。

41. B

Northern Ireland and Scotland have their own banknotes, which are valid anywhere in the UK. However, shops and businesses do not have to accept them.

北愛爾蘭和蘇格蘭都有自己的鈔票，這些鈔票在英國任何地方都有效。但是，政府並不規定商店和企業必定要接受它們。

42. A

43. A

44. A

45. A

Margaret Thatcher used the privatization of nationalized industries to structurally reform the economy and exercise legal control over union power.

戴卓爾夫人利用國有工業的私有化來進行經濟結構改革，並對工會權力實行法律控制。

46. A

After the outbreak of the Black Death, a new social class emerged, including owners of large tracts of land (later called gentry), and people left the countryside to live in towns. In cities and towns, the growth of wealth has led to the development of a powerful middle class.

黑死病爆發後，出現了一個新的社會階層，其中包括大片土地的所有者（後稱紳士），人們離開農村居住在城鎮中。在城鎮，財富的增長導致了強大的中產階級的發展。

47. B

In the UK, a National Lottery is drawn every week.

在英國，每週都會抽籤一張國家彩票。

48. B

The jury must listen to the evidence presented in the trial and then determine "guilty" or "not guilty" based on what they heard. In Scotland, it is also possible to make a third "not proven'" ruling.

陪審團必須聽取審判中提供的證據，然後根據他們所聽到的來判定「有罪」或「無罪」。在蘇格蘭，也有可能做出第三種「未經證實」的裁決選擇。

49. B

The National Insurance Number alone does not prove to the employer that you are entitled to work in the UK. Also, the 'National Insurance Number' is also known as 'NI Number'.

僅國家保險號碼並不能向僱主證明您有權在英國工作。另外，國家保險號碼亦稱作「NI Number」。

50. A

The United Kingdom is one of the five permanent members of the United Nations Security Council.

英國是聯合國安全理事會五個常任理事國之一。

51. A

52. B
要申請成為英國的永久居民或公民，您需要對英國的生活有充分的了解，並且能夠說和讀英語。

53. A

54. A
Drinking in public places: Some places have alcohol-free zones, and you cannot drink in public places. The police can also confiscate alcohol or take young people away from public places. You may be fined or arrested.
在公共場所喝酒：某些地方有無酒精區，您不能在公共場所喝酒。警察還可以沒收酒精或將年輕人帶離公共場所。您可能會被罰款或逮捕。

55. B
Mary I (the Queen of Scotland) was a Catholic.
瑪麗一世是位天主教徒。

56. B
At 11am on the morning of the anniversary, there was a two-minute silence, and the wreath was tied down on the monument in Whitehall, London.
週年紀念日上午11時，沉默了兩分鐘，花圈被繫在倫敦白廳的和平紀念碑上。

57. A
In England, Wales and Northern Ireland, if the defendant is between the ages of 10 and 17, the case is usually heard in a youth court before up to three specially trained magistrates or a District Judge.
在英格蘭，威爾士和北愛爾蘭，如果被告年齡在10到17歲之間，通常會在青年法庭上審理此案，然後由三名經過特別訓練的裁判官或地方法官審理。

58. B

Royal Ascot is a 5-day race meeting in Berkshire, attended by members of the Royal Family.

雅士谷賽馬日是一項為期五天的賽馬競賽活動，地點在伯克郡，主要參加者都是皇室成員。

59. B

In Scotland, some programs specific to Scotland are shown, and there is also a channel that offers programs in Gaelic.

蘇格蘭的電視台，一些節目是專門播放給蘇格蘭人收看，當中更有一個電視台頻頻，會提供蓋爾語節目。

60. B

The United Nations was established after the Second World War.

聯合國是第二次世界大戰後成立的。

61. B

In May 2010, this was the first time since February 1974 that no political party in the UK had obtained an overall majority in the general election. The Conservative Party and the Liberal Democrats formed a coalition, and Conservative Party leader David Cameron became the Prime Minister.

自1974年2月以來，這是自1974年2月以來英國任何政黨首次在大選中獲得絕對多數席位。保守黨和自由民主黨組成聯盟，保守黨領袖大衛卡梅倫成為總理。

62. B

It is a criminal offence to cause harassment, fright or distress to another person because of his religion or ethnic origin.

因宗教或種族出身而對他人造成騷擾、恐嚇或困擾是刑事罪行。

63. A

64. A

65. B

The House of Lords is generally more independent of the government than the House of Commons.

上議院通常比下議院更獨立於政府。

66. B

In Wales, many people speak Welsh – a completely different language from English – and it is taught in schools and universities.

在威爾斯，許多人說威爾斯語，那是一種與英語完全不同的語言，並在學校和大學中教授。

67. A

2.3

二選一題
Select The Statement Which You Think Is Correct

1. **Which of the following statements is CORRECT?**

 以下哪個陳述是正確的？

 （A）A jury is made up of members of the public who have applied to be part of it.

 （A）陪審團由申請加入的公眾人士組成。

 （B）A jury is made up of members of the public chosen at random from the local electoral register

 （B）陪審團由從當地選舉登記冊中隨機選出的公眾組成。

2. **Which of the following statements is CORRECT?**

 以下哪個陳述是正確的？

 （A）County Courts handles various civil disputes, including family matters, breach of contract and divorce.

 （A）郡法院負責處理各種民事糾紛，包括家庭事務、違約訴訟和離婚官司。

 （B）County Courts deal with a wide range of criminal disputes, including family matters, breach of contract and divorce.

 （B）郡法院處理廣泛的刑事爭端，包括家庭事務、違反合同和離婚。

3. **Which of the following statements is CORRECT?**

 以下哪個陳述是正確的？

 （A）Britain has a written constitution.

 （A）英國有成文憲法。

 （B）Britain has NO written constitution.

 （B）英國沒有成文憲法。

4. **Which of the following statements is CORRECT?**

 以下哪個陳述是正確的？

 （A）Stonehenge in Northern Europe helped archaeologists gain a deeper understanding of the way people lived in the late Stone Age.

 （A）位於北歐的巨石陣能幫助考古學家更深入地了解了石器時代晚期人們的生活方式。

 （B）Shara Brae in Northern Europe helped archaeologists gain a deeper understanding of the way people lived in the late Stone Age.

 （B）位於北歐的薩拉·布雷能幫助考古學家更深入地了解了石器時代晚期人們的生活方式。

5. **Which of the following statements is CORRECT?**

 以下哪個陳述是正確的？

 （A）When international crises and peace threats occur, the UN Security Council will carry out recommend action.

 （A）當發生國際危機和和平威脅時，聯合國安理會採取建議的行動。

 （B）In the event of a natural disaster, the UN Security Council will take recommended humanitarian actions

 （B）萬一發生自然災害，聯合國安理會將採取建議的人道主義行動。

6. **Which of the following statements is CORRECT?**

 以下哪個陳述是正確的？

 （A）RSPB works for the prevention of cruelty to children.

 （A）RSPB 致力防止虐待兒童的情況發生。

 （B）NSPCC works for the prevention of cruelty to children.

 （B）NSPCC 致力防止虐待兒童的情況發生。

7. **Which of the following statements is CORRECT?**

 以下哪個陳述是正確的？

 （A）Catherine of Aragon (the first wife of Henry VIII) from Spain.

 （A）亨利八世的第一任妻子阿拉貢的凱瑟琳來自西班牙。

 （B）Catherine of Aragon (the first wife of Henry VIII) from France.

 （B）亨利八世的第一任妻子阿拉貢的凱瑟琳來自法國。

8. **Which of the following statements is CORRECT?**

 以下哪個陳述是正確的？

 （A）William II is married to the Queen of the United Kingdom.

 （A）威廉二世跟英格蘭女王結婚。

 （B）Prince Philip, Duke of Edinburgh, is married to the Queen of the United Kingdom.

 （B）英國女王與愛丁堡公爵菲臘親王結婚。

9. **Which of the following statements is CORRECT?**

 以下哪個陳述是正確的？

 （A）In Britain, people over 75 can apply for a free TV licence.

 （A）75歲以上的人可以申請免費的電視許可證。

 （B）In Britain, people over 80 can apply for a free TV licence.

 （B）80歲以上的人可以申請免費的電視許可證。

10. **Which of the following statements is CORRECT?**

 以下哪個陳述是正確的？

 （A）In Britain, pubs usually open 12nn on SUNDAYS in the UK.

 （A）在英國，酒吧星期日通常在正午12時開放。

 （B）In Britain, pubs usually open 1pm on SUNDAYS in the UK.

 （B）在英國，酒吧星期日通常在下午1時開放。

11. Which of the following statements is CORRECT?

以下哪個陳述是正確的？

（A）10 Downing Street is the official home of the Prime Minister.

（A）唐寧街10號是英國首相的官邸。

（B）Buckingham Palace is the official home of the Prime Minister.

（B）白金漢宮是英國首相的官邸。

12. Which of the following statements is CORRECT?

以下哪個陳述是正確的？

（A）84% of the total British population is located in England alone.

（A）僅在英格蘭，就有84%的英國人口居住。

（B）48% of the total British population is located in England alone.

（B）僅在英格蘭，就有48%的英國人口居住。

13. Which of the following statements is CORRECT?

以下哪個陳述是正確的？

（A）The population of the UK in 2020 was over 67 million people.

（B）2020年，英國的人口超過6700萬人。

（A）The population of the UK in 2020 was over 76 million people.

（B）2020年，英國的人口超過7600萬人。

14. **Which of the following statements is CORRECT?**

 以下哪個陳述是正確的？

 （A）Rose is associated with England.

 （A）玫瑰跟英格蘭有關。

 （B）Thistle is associated with England.

 （B）薊花跟英格蘭有關。

15. **Which of the following statements is CORRECT?**

 以下哪個陳述是正確的？

 （A）Robert Burns was a Scottish poet.

 （A）羅伯特·伯恩斯是一位蘇格蘭詩人。

 （B）Robert Burns was a British musicians.

 （B）羅伯特·伯恩斯是一位英國音樂家。

16. **Which of the following statements is CORRECT?**

 以下哪個陳述是正確的？

 （A）April's Fool Day is the name of the people joking with each other until noon.

 （A）直到中午彼此開玩笑的節日叫愚人節。

 （B）Halloween is the name of the people joking with each other until noon.

 （B）直到中午彼此開玩笑的節日叫萬聖節。

17. **Which of the following statements is CORRECT?**

 以下哪個陳述是正確的？

 （A）First World War ended at 11th November 1918.

 （A）第一次世界大戰於1918年11月11日結束。

 （B）First World War ended at December 9, 1918.

 （B）第一次世界大戰於1918年12月9日結束。

18. **Which of the following statements is CORRECT?**

 以下哪個陳述是正確的？

 （A）The relationship between the monarch and the government is: Advise, warn and encourage the government's decisions.

 （A）君主與政府之間的關係是：提出建議、警告並鼓勵政府決策。

 （B）The relationship between the monarch and the government is: Advise and approve the government's decisions.

 （B）君主與政府之間的關係是：建議並批准政府的決定。

19. **Which of the following statements is CORRECT?**

 以下哪個陳述是正確的？

 （A）Henry VIII established the Church of England.

 （A）亨利八世創立了英格蘭教堂。

 （B）Elizabeth I established the Church of England.

 （B）伊莉莎白一世創立了英格蘭教堂。

20. **Which of the following statements is CORRECT?**

 以下哪個陳述是正確的？

 （A）If you watch TV but do not have a TV license, you will be fined up to £500.

 （A）如果您看電視但沒有電視執照，將被處以最高500英鎊的罰款。

 （B）If you watch TV but do not have a TV license, you will be fined up to £1,000.

 （B）如果您看電視但沒有電視執照，將被處以最高1,000英鎊的罰款。

21. **Which of the following statements is CORRECT?**

 以下哪個陳述是正確的？

 （A）Members of the European Parliament (MEPs) are elected on the basis of proportional representation.

 （A）選舉歐洲議會議員是以比例代表做基礎。

 （B）Members of the European Parliament (MEPs) are elected on the basis of personal achievements.

 （B）選舉歐洲議會議員是以個人成就做基礎。

22. **Which of the following statements is CORRECT?**

 以下哪個陳述是正確的？

 （A）The name 'The Enlightenment' is given to the period in the 18th century when new ideas about politics, philosophy and science were developed.

 （A）在18世紀，關於政治，哲學和科學的新思想得到發展的時代的名字叫「啟蒙時代」。

 （B）The name 'The Glorious Revolution' is given to the period in the 18th century when new ideas about politics, philosophy and science were developed.

 （B）在18世紀，關於政治，哲學和科學的新思想得到發展的時代的名字叫「光榮革命」。

23. **Which of the following statements is CORRECT?**

 以下哪個陳述是正確的？

 （A）The Chancellor of the Exchequer is responsible for the economy.

 （A）財政大臣對經濟負責。

 （B）The Chancellor of the Exchequer is responsible for the Defence.

 （B）財政大臣對國防負責。

24. **Which of the following statements is CORRECT?**

 以下哪個陳述是正確的？

 （A）The Jewish celebration 'Hanukkah' normally celebrated in November or December.

 （A）猶太慶祝活動「光明節」通常在十一月或十二月舉行。

 （B）The Jewish celebration 'Hanukkah' normally celebrated in June or July.

 （B）猶太慶祝活動「光明節」通常在六月或七月舉行。

25. **Which of the following statements is CORRECT?**

 以下哪個陳述是正確的？

 （A）Welsh people call Budika 'Buddug'.

 （A）威爾斯人稱布迪卡做「Buddug」。

 （B）Welsh people call Budika 'Buddog'.

 （B）威爾斯人稱布迪卡做「Buddog」。

26. **Which of the following statements is CORRECT?**

 以下哪個陳述是正確的？

 （A）UK residents need to register their car or motorcycle at the DVLA(Driver and Vehicle Licensing Agency).

 （A）英國居民需要在駕駛員和車輛執照頒發機構「DVLA」註冊汽車或電單車。

 （B）UK residents need to register their car or motorcycle at the Ministry of Transport (MOT).

 （B）英國居民需要在交通運輸部（MOT）註冊汽車或電單車。

27. **Which of the following statements is CORRECT?**

 以下哪個陳述是正確的？

 （A）The Duke of Wellington defeated Emperor Napoleon at the Battle of Waterloo in 1815.

 （A）惠靈頓公爵在1815年的滑鐵盧戰役中擊敗了拿破崙。

 （B）Admiral Nelson defeated Emperor Napoleon at the Battle of Waterloo in 1815.

 （B）尼爾遜海軍上將在1815年的滑鐵盧戰役中擊敗了拿破崙。

28. **Which of the following statements is CORRECT?**

 以下哪個陳述是正確的？

 （A）The symbol of the House of Tudor is a red rose with a white rose inside it.

 （A）都鐸王朝的象徵是內有白玫瑰的紅玫瑰。

 （B）The symbol of the House of Tudor is a white rose with a red rose inside it.

 （B）都鐸王朝的象徵是白玫瑰中有紅玫瑰。

29. **Which of the following statements is CORRECT?**

 以下哪個陳述是正確的？

 （A）Famous economist Adam Smith developed ideas about economics during the 18th century, which are still referred to today.

 （A）著名經濟學家亞當·史密夫在18世紀提出自己的經濟學觀點，到今天仍然被提及。

 （B）Famous economist Henry George developed ideas about economics during the 18th century, which are still referred to today.

 （B）著名經濟學家亨利·喬治在18世紀提出自己的經濟學觀點，到今天仍然被提及。

30. **Which of the following statements is CORRECT?**

 以下哪個陳述是正確的？

 （A）Pubs usually open at 12nn on Sundays.

 （A）酒吧星期日通常在中午12時營業。

 （B）Pubs usually open at 10am on Sundays.

 （B）酒吧星期日通常在上午10時營業。

31. Which of the following statements is CORRECT?

以下哪個陳述是正確的？

（A）During Eid ul Adha, many Muslims sacrificed an animal for food.

（A）在宰牲節期間，許多穆斯林犧牲了一隻動物作食物。

（B）During Eid ul Adha, many Muslims sacrificed human for food.

（B）在宰牲節期間，許多穆斯林犧牲了活人作食物。

32. Which of the following statements is CORRECT?

以下哪個陳述是正確的？

（A）People under 16 are not allowed to play the National Lottery.

（A）16歲以下的人不得參加國家獎券。

（B）People under 18 are not allowed to play the National Lottery,

（B）18歲以下的人不得參加國家獎券。

33. Which of the following statements is CORRECT?

以下哪個陳述是正確的？

（A）Royal Ascot is a five-day race meeting attended by members of the Royal Family, takes place in Berkshire.

（A）雅士谷是伯克郡王室成員舉行的為期五天的比賽。

（B）Royal Ascot is a five-day race meeting attended by members of the Royal Family, takes place in Luton.

（B）雅士谷是盧頓王室成員舉行的為期五天的比賽。

34. **Which of the following statements is CORRECT?**

 以下哪個陳述是正確的？

 （A）Julius Caesar was the first person to lead a Roman invasion in Britain in 55 BC.

 （A）凱撒大帝是公元前55年第一個入侵羅馬的英國人。

 （B）Emperor Claudius was the first person to lead a Roman invasion in Britain in 55 BC.

 （B）克勞迪烏斯皇帝是公元前55年第一個入侵羅馬的英國人。

35. **Which of the following statements is CORRECT?**

 以下哪個陳述是正確的？

 （A）J. R. R. Tolkien wrote "The Lord of the Rings".

 （A）托爾金寫了《魔戒電影三部曲》。

 （B）JK Rowling "The Lord of the Rings".

 （B）JK羅琳寫了《魔戒電影三部曲》。

36. **Which of the following statements is CORRECT?**

 以下哪個陳述是正確的？

 （A）The Magistrates' Court deals with minor criminal cases in England, Wales and Northern Ireland.

 （A）在英格蘭、威爾斯和北愛爾蘭，地方法院負責處理小型刑事案件。

 （B）The High Court deals with minor criminal cases in England, Wales and Northern Ireland.

 （B）在英格蘭、威爾斯和北愛爾蘭，高等法院負責處理小型刑事案件。

37. Which of the following statements is CORRECT?

以下哪個陳述是正確的？

（A）The name 'Round barrows' is given to the tombs where people buried their dead during the Bronze Age.

（A）人們在青銅時代埋葬死者的墳墓的名字叫「手推車」。

（B）The name 'Hill forts' is given to the tombs where people buried their dead during the Bronze Age.

（B）人們在青銅時代埋葬死者的墳墓的名字叫「山堡」。

38. Which of the following statements is CORRECT?

以下哪個陳述是正確的？

（A）The Northern Ireland Parliament cannot make decisions on Defence.

（A）北愛爾蘭議會不能就防禦問題作出決定。

（B）The Northern Ireland Parliament cannot make decisions on Education.

（B）北愛爾蘭議會不能就教育問題作出決定。

39. Which of the following statements is CORRECT?

以下哪個陳述是正確的？

（A）According to the 2011 Census, less than 0.5% of the population identified themselves as Buddhist.

（A）根據2011年的人口普查，英國有不到0.5％的人認為自己是佛教徒？

（B）According to the 2011 Census, less than 5% of the population identified themselves as Buddhist.

（B）根據2011年的人口普查，英國有不到5％的人認為自己是佛教徒？

40. Which of the following statements is CORRECT?

以下哪個陳述是正確的？

（A）Jayne Torvill and Christopher Dean won ice dancing gold medals at the Olympic Games in 1984.

（A）托維爾和迪安在冰舞比賽中贏得1984年奧運會金牌。

（B）Jayne Torvill and Christopher Dean won ice dancing gold medals at the Olympic Games in 1984.

（B）托維爾和迪安在馬拉松比賽中贏得1984年奧運會金牌。

41. Which of the following statements is CORRECT?

以下哪個陳述是正確的？

（A）The first verse of the National Anthem of the UK 'God save the Queen' is 'God save our gracious Queen!'

（A）英國國歌《上帝拯救女王》的第一節是：「上帝保佑我們善良的女王」。

（B）The first verse of the National Anthem of the UK 'Long live our noble Queen!'

（B）英國國歌《上帝拯救女王》的第一節是：「我們高貴的女王萬歲！」。

42. **Which of the following statements is CORRECT?**

 以下哪個陳述是正確的？

 （A）British Prime Minister Winston Churchill is known for "I have nothing but blood, toil, tears and sweat"?

 （A）英國首相邱吉爾以「我只剩鮮血、辛勞、淚水和汗水」聞名。

 （B）British Prime Minister Anthony Eden is known for "I have nothing but blood, toil, tears and sweat"?

 （B）英國首相安東尼·伊甸園以「我只剩鮮血、辛勞、淚水和汗水」聞名。

43. **Which of the following statements is CORRECT?**

 以下哪個陳述是正確的？

 （A）Bulgaria did not belong to the Allies during World War I.

 （A）第一次世界大戰期間，保加利亞不是盟國成員。

 （B）Australia did not belong to the Allies during World War I.

 （B）第一次世界大戰期間，澳洲不是盟國成員。

44. **Which of the following statements is CORRECT?**

 以下哪個陳述是正確的？

 （A）The money from TV licences used is to: pay for the British Broadcasting Corporation (BBC).

 （A）電視牌照費是用來向英國廣播公司付費。

 （B）The money from TV licences used is to: pay for the private channels.

 （B）電視牌照費是用來向付費私人頻道付費。

45. Which of the following statements is CORRECT?

以下哪個陳述是正確的？

（A）The Commonwealth is an association of countries that support each other and work together towards shared goals in democracy and development.

（A）英聯邦是一個相互支持並共同努力實現民主與發展共同目標的跨國協會。

（B）The Commonwealth is an organisation responsible for the protection and promotion of human rights in its member countries.

（B）英聯邦是一個負責在其成員國保護和促進人權的組織。

46. Which of the following statements is CORRECT?

以下哪個陳述是正確的？

（A）Sir Christopher Wren designed St Paul's Cathedral after it was destroyed by a fire in 1666.

（A）基斯杜化雷恩爵士設計出聖保祿大教堂。

（B）Robert Burns designed St Paul's Cathedral after it was destroyed by a fire in 1666.

（B）羅拔‧伯恩斯設計出聖保祿大教堂。

47. Which of the following statements is CORRECT?

以下哪個陳述是正確的？

（A）Mozambique belongs to the Commonwealth.

（A）莫桑比克屬於英聯邦。

（B）Mali belongs to the Commonwealth.

（B）馬里屬於英聯邦。

48. Which of the following statements is CORRECT?

以下哪個陳述是正確的？

（A）Almost everybody who is in paid work has to pay national insurance contributions in the UK.

（A）幾乎所有從事有償工作的人都必須在英國支付國家保險金。

（B）Everybody under the age of 70 has to pay national insurance contributions in the UK.

（B）所有70歲以下的人都必須在英國支付國家保險金。

49. Which of the following statements is CORRECT?

以下哪個陳述是正確的？

（A）Northern Ireland does not belong to Great Britain.

（A）北愛爾蘭不屬於英國。

（B）Wales does not belong to Great Britain.

（B）威爾斯不屬於英國。

50. Which of the following statements is CORRECT?

以下哪個陳述是正確的？

（A）Bradley Wiggins was the first Briton to win the 'Tour de France'.

（A）布拉德利·威金斯是第一位贏得環法自行車賽的英國人。

（B）Andy Murray was the first Briton to win the 'Tour de France'.

（B）安迪·梅利是第一位贏得環法自行車賽的英國人。

51. Which of the following statements is CORRECT?

以下哪個陳述是正確的？

（A）In the UK, you have to be 18 to go into betting shops.

（A）在英國，您必須年滿18歲才能進入博彩店。

（B）In the UK, you have to be 16 to go into betting shops.

（B）在英國，您必須年滿16歲才能進入博彩店。

52. Which of the following statements is CORRECT?

以下哪個陳述是正確的？

（A）In 1689, the'Bill of Rights' confirmed the rights of Parliament and the limits of the king's power.

（A）1689年的《權利清單》確認了國會的權力和國王的權力。

（B）In 1689, the'Bill of Rights' confirmed the supreme power of the troop.

（B）1689年的《權利清單》確認了軍隊的最高權力。

53. Which of the following statements is CORRECT?

以下哪個陳述是正確的？

（A）Robert Adam designed the Clifton Suspension Bridge located over the Avon George.

（A）羅拔·阿當設計了在雅芳市喬治敦上空的克利夫頓吊橋。

（B）Isambard Kingdom Brunel designed the Clifton Suspension Bridge located over the Avon George.

（B）伊莎博德王國的布魯內爾誰設計了在雅芳市喬治敦上空的克利夫頓吊橋。

54. Which of the following statements is CORRECT?

以下哪個陳述是正確的？

（A）Bulgaria was not part of the Allied Powers during the First World War.

（A）第一次世界大戰期間，保加利亞不是協約國成員。

（B）Serbia was not part of the Allied Powers during the First World War.

（B）第一次世界大戰期間，塞爾維亞不是協約國成員。

55. Which of the following statements is CORRECT?

以下哪個陳述是正確的？

（A）The Olympic Games have been hosted in the UK for three times.

（A）英國舉辦了三屆奧運會。

（B）The Olympic Games have been hosted in the UK for two times.

（B）英國舉辦了兩屆奧運會。

56. Which of the following statements is CORRECT?

以下哪個陳述是正確的？

（A）Films first shown publicly in the UK in 1887.

（A）在1887年，電影在英國首次放映。

（B）Films first shown publicly in the UK in 1896.

（B）在1896年，電影在英國首次放映。

Answer:
答案及解析：

1. B

2. A

There are 216 County Courts in England and Wales, which mainly hear most civil disputes, some family matters and bankruptcy cases.

英格蘭和威爾斯合共有216所郡法院、郡法院主要審理大部份民事訴訟、少部分的家事案件，以及破產案件。

3. B

The British constitution is not written down in any single document, and therefore it is described as 'unwritten'. This is mainly because the UK, unlike America or France, has never had a revolution which led permanently to a totally new system of government.

The British Constitution is not written in any single document, so it was described as 'unwritten'. This is mainly because Britain, unlike the United States or France, has never had a revolution that permanently leads to a new government system.

英國憲法沒有寫在任何單一文件中，因此被描述為「未成文」。這主要是因為英國與美國或法國不同，從未發生過永久導致新政府體制的革命。

4. B

Skara Brae, located in Orkney, on the north coast of Scotland, is the best-preserved prehistoric village in Northern Europe. It has helped archaeologists learn more about the way people lived at the end of the Stone Age.

Skara Brae位於蘇格蘭北海岸的奧克尼，是北歐保存最完好的史前村莊。它幫助考古學家了解石器時代末期人們的生活方式。

5. A

6. B

NSPCC is 'the National Society for the Prevention of Cruelty to Chindren'.

NSPCC的中文全名是「全國防治虐待兒童協會」。

7. A

Catherine of Aragon was a Spanish princess.

阿拉貢的凱瑟琳是西班牙公主。

8. B

Prince Philip, Duke of Edinburgh is the husband of Queen Elizabeth II of the United Kingdom

愛丁堡公爵菲臘親王是英國伊莉莎白二世女王的丈夫。

9. A

People over 75 years old can apply for a free TV license, and blind people can get a 50% discount.

75歲以上的人可以申請免費的電視許可證,盲人可以享受50%的折扣。

10. A

Pub usually opens at 11am in the morning (12nn on Sundays).

酒吧通常在早上11時營業(但星期日的開門時間為中午12時)。

11. A

The Prime Minister's official residence is located at 10 Downing Street in central London, close to the Houses of Parliament. He or she also has a country house called Chequers on the outskirts of London.

英國首相的官邸設於倫敦市中心的唐寧街10號,位置靠近國會大廈。首相在倫敦郊區還有一座叫Checkers的別墅。

12. A

The population is unevenly distributed in the four parts of the UK. England always accounts for more or less 84% of the total population, Wales is about 5%, Scotland is

slightly more than 8%, and Northern Ireland is less than 3%.
英國的人口在其四個地區分佈不均：英格蘭總是佔總人口的約84%，威爾斯約為5%，蘇格蘭略高於8%，北愛爾蘭則不到3%。

13. A

The population of the UK in 2020 was over 67 million people.
2020年，英國的人口超過6700萬人。

14. A

Rose is the flower associated with England.
玫瑰是與英格蘭相關的花。

15. A

Robert Burns was a Scottish poet. He was also known as 'The Bard'.
羅伯特·伯恩斯在蘇格蘭被稱為「吟遊詩人」。

16. A

April Fool's Day (April 1) is a day when people joke with each other before noon. There are often stories of April Fools' jokes on TV and newspapers.
愚人節（4月1日）是人們在中午之前開玩笑的日子。電視和報紙上經常有愚人節笑話的故事。

17. A

The First World War ended at 11am on Nov 11, 1918 with victory for Britain and its allies.
第一次世界大戰於1918年11月11日上午11點結束。英國及其盟國獲勝。

18. A

The monarch hold regular meetings with the Prime Minister and can advise, warn and encourage, but the decisions on government policies are made by the Prime Minister and Cabinet.
君主和首相會定期開會，可以提供建議、警告和鼓勵，但政府政策的決定由總理和內閣決定。

19. A

In order to divorce his first wife, Henry VIII needed the Popo's approval. When the Pope refused, Henry established the Church of England. In this new church, the king, not the Pope, would have the power to appoint bishops and order how people should worship.

為了與第一任妻子離婚，亨利八世需要教皇的批准。當教皇拒絕時，亨利建立了英格蘭教堂。在這個新教堂中，國王（而不是教皇）有權任命主教並命令人們禮拜。

20. B

21. A

Participation in elections to the European Parliament uses a proportional representation system, where seats are allocated to each party, depending on the total number of votes it wins.

參加歐洲議會的選舉使用比例代表制，根據贏得的選票總數，在每個政黨中分配席位。

22. A

Age of Enlightenment, also known as Age of Reason, refers to an intellectual and cultural movement that occurred in Europe in the 17th and 18th centuries.

啟蒙時代或啟蒙運動（Age of Enlightenment），又稱理性時代（Age of Reason），是指在17世紀及18世紀歐洲地區發生的一場知識及文化運動。

23. A

24. A

Hanukkah is in November or Decemberand is celebrated for eight days.

光明節在11月或12月舉行，慶祝八天。

25. A

Boudicca was one of the tribal leaders who fought against the Romans. She is the queen of the Iceni in what is now eastern England. Welsh people call her 'Buddug'.

布迪卡（Boudicca）是與羅馬人作戰的部落首領之一，她是現今英格蘭東部的阿西尼女王。威爾斯人稱布迪卡做「Buddug」（比達格）。

26. A

DVLA website: www.dvla.gov.uk

駕駛員和車輛許可代理（DVLA）的網址是：www.dvla.gov.uk

27. A

The French War ended with the defeat of Emperor Napoleon at the Duke of Wellington at the Battle of Waterloo in 1815.

1815年，法國戰爭隨著滑鐵盧戰役中惠靈頓公爵擊敗拿破崙皇帝而結束。

28. A

The symbol of the Tudor dynasty is a red rose with a white rose inside, to show that the York family and the Lancaster family are now allies.

都鐸王朝的象徵是一朵紅玫瑰，裡面是白玫瑰，表明約克家族和蘭開斯特家族現在是盟友。

29. A

In the 18th century, new ideas about politics, philosophy, and science were developed. This is often referred to as the "Enlightenment". Many of the great thinkers of the Enlightenment were Scots. Adam Smith put forward ideas about economics, which are still cited today.

在18世紀，有關政治，哲學和科學的新思想得到了發展。這通常被稱為「啟蒙運動」。啟蒙運動的許多偉大思想家都是蘇格蘭人。亞當·斯密（Adam Smith）提出了有關經濟學的觀點，至今仍在引用。

30. A

31. A

32, A

33. A

34.A

35. A

36. A

In England, Wales and Northern Ireland, most of the minor criminal cases are handled by Magistrates' Court. In Scotland, minor criminal offences are prosecuted in Justice of the Peace Court.

在英格蘭，威爾斯和北愛爾蘭，大多數較小的刑事案件由地方法院處理。在蘇格蘭，治安法院處理輕微的刑事犯罪。

37. A

During the Bronze Age, people lived in round houses and buried their dead in tombs called round barrows.

在青銅時代，人們居住在圓形房屋中，並將死者埋在稱為圓形推車的墳墓中。

38. A

The Northern Ireland Assembly can make decisions on agriculture, education, health, environment and social services. However, it cannot make decisions for National Defense.

北愛爾蘭議會可以就教育、農業、環境、衛生和社會服務做出決定。它不能為國防作決定。

39. A

40. A

Jayne Torvill and Christopher Dean won gold medals for ice dancing at the 1984 Olympics and are one of Britain's greatest Olympians.

賈恩·托維爾（Jayne Torvill）和克里斯托弗·迪恩（Christopher Dean）在1984年奧運會上以冰舞贏得金牌，並且是英國最偉大的奧運選手之一。

41. A

42. A

During World War II, Winston Churchill gave a lot of famous speeches, including lines you might still hear: "I have nothing but blood, hard work, tears and sweat. Other things'". This was his first speech to the House of Commons after he became Prime Minister in 1940.

在第二次世界大戰期間，邱吉爾發表過許多著名演講，當中包括你可能仍然會聽到的名句：「我只剩鮮血、辛勞、淚水和汗水。」這是他在1940年就任英國首相後，在下議院發表的第一次講話。

43. A

44. A

The BBC is the largest broadcasting company in the world. It is the only media organization independent of the government and fully funded by the state wholly.

英國廣播公司（BBC）的費用。這是一家提供電視和廣播節目的公共廣播公司。英國廣播公司是世界上最大的廣播公司。它是唯一一家獨立於政府並由國家完全資助的媒體組織。

45. A

The Commonwealth is an association of nations that support each other and work together to achieve the common goal of democracy and development. Most member states were once part of the British Empire, although there are some countries that have not joined.

英聯邦是相互支持，共同努力實現民主與發展的共同目標的國家協會。大多數成員國曾經是大英帝國的一部分，儘管有些國家尚未加入。

46. A

In 1666, a fire destroyed most of the city of London, including many churches and St. Paul's Cathedral. London has rebuilt the new St. Paul's Cathedral designed by the famous architect Sir Christopher Wren.

1666年，一場大火燒毀了倫敦大部分城市，包括許多教堂和聖保祿大教堂。倫敦重建了由著名建築師克里斯托弗·雷恩爵士設計的新聖保祿大教堂。

47. A

48. A

Almost all persons engaged in paid work in the UK, including self-employed persons, must pay National Insurance Contributions..

幾乎所有在英國從事有償工作的人，包括自僱人士，都必須支付國民保險。

49. A

'Great Britain' refers only to England, Scotland and Wales, not to Northern Ireland. The official name of the country is the United Kingdom of Great Britain and Northern Ireland.

「大不列顛」僅指英格蘭、蘇格蘭和威爾斯，而不是北愛爾蘭。該國的正式名稱是大不列顛及北愛爾蘭聯合王國。

50. A

51. A

52. A

The Bill of Rights of 1689 confirmed the power of parliament and the power of the king. The Parliament controls who may be the monarch and declares that the king or queen must be a Protestant.

1689年的《權利清單》確認了議會的權力和國王的權力。議會控制誰可能是君主，並宣布國王或王后必須是新教徒。

53. B

54. A

During World War I, Bulgaria was part of the Central Power.

During World War I, Bulgaria was part of the central power.

第一次世界大戰期間，保加利亞是同盟國的一部分。

55. A

The United Kingdom has hosted the Olympic games three times: 1908, 1948 and 2012. 英國曾三屆舉辦奧運會，分別是：1908年、1948年和2012年。

56. B

In 1896, films were first shown publicly in the UK. Film screenings became popular very quickly .

電影於1896年在英國首次公開放映，並隨即大受歡迎。

2.4

四選二題
Select Two Correct Answers From Four Options

1. Which of the followings are environmental charities? (Choose TWO)

 以下哪兩間是保護環境的慈善機構？（選兩個）

 （A）Environmental Working Group（EWG）
 （B）National Trust
 （C）Friends of the Earth
 （D）PDSA

2. Which TWO of the followings you need to have in order to become a permanent resident or citizen of the UK?

 如要成為英國的永久居民或公民，你需要以下哪兩項？

 （A）UK driving license英國駕駛執照
 （B）Able to speak and read English會說英語並閱讀
 （C）Deep understanding of British life對英國生活有相當的理解
 （D）poses a university degree of UK持有英國大學學位

3. **The NATO (North Atlantic Treaty Organization) is composed of European and North American countries, and its purpose is TWO:**

 北大西洋公約組織由歐洲和北美國家組成，其目的是兩個：

 （A）Protect and promote human rights in these countries在這些國家保護和促進人權

 （B）Help each other if they come under attack當成員國受攻擊時，要互相幫助

 （C）Maintain peace among all members維護全體成員之間的和平

 （D）Promote free trade between these countries促進成員國之間的自由貿易

4. **Which of the following water sports are popular in the UK? (Choose TWO)**

 下列哪些水上運動在英國大受歡迎？（選兩個）

 （A）Surfing衝浪

 （B）Rowing賽艇

 （C）Sailing帆船運動

 （D）Waterpolo水球

5. **In which TWO movie categories does the UK continue to perform particularly well?**

 英國在哪兩個電影類別中尤其表現出色？

 （A）Special effects movies特技效果電影

 （B）Action films動作片

 （C）Animation films動畫電影

 （D）Thrillers films驚悚片

6. **Which of the following charities work with homeless people? (Choose TWO)**

 以下哪些慈善機構與無家可歸的人合作？（選兩個）

 （A）Friends of the Earth

 （B）Shelter

 （C）Crisis

 （D）Oxfam

7. **How to contact Members of Parliament (choose TWO)?**

 如何聯絡國會議員（選兩個）？

 （A）By writing letter撰寫信件

 （B）Go to your local council and make an appointment到你居住地的議會預約

 （C）Call his/her office directly致電議員的辦公室

 （D）Via Facebook透過面書

8. **What will be tested with a driving test (choose TWO)?**

 駕駛考試會測試什麼（選兩個）？

 （A）Health condition健康狀況

 （B）Knowledge知識

 （C）Practical skills實際技能

 （D）IQ智商

9. Which of the following movies are directed by David Lean? (Choose TWO)

哪部電影由大衛連執導？（選兩個）

（A）Brief Encounter

（B）The 39 Steps

（C）Lawrence of Arabia

（D）Chariots of Fire

10. Which country/region developed the Concorde aircraft? (Choose TWO)

哪個國家/地區研發了和諧式客機？（選兩個）

（A）Germany德國

（B）United States美國

（C）United Kingdom英國

（D）France法國

11. As a permanent resident or citizen of the UK, which two of the following responsibilities will you assume?

作為英國的永久居民或公民，您將承擔以下哪兩項責任？

（A）Obey the law遵守法律

（B）Go to church on Sundays星期天上教堂

（C）Take care of your area and environment注意您所在的地區和環境衛生

（D）Military service服兵役

12. During the "Swinging Sixties", which of the following TWO social laws were relaxed?

在「搖擺倫敦」期間，政府放寬了以下哪兩項法律？

（A）The law of abortion墮胎法

（B）The law of divorce離婚法

（C）The law of immigration移民法

（D）The law of business商業法

13. Which combination of TWO languages forms the basis of English?

以下哪兩種語言的組合，構成了英語的基礎？

（A）French法文

（B）Latin拉丁文

（C）Norman French 法國諾曼第語

（D）Anglo-Saxon盎格魯撒克遜語

14. Which TWO of the following are famous British horse racing events?

以下哪兩個是英國著名的賽馬比賽？

（A）The Major Race主要賽

（B）Royal Ascot皇家雅士谷賽馬

（C）The Grand National英國國家障礙賽馬大賽

（D）Six Nations Championship六國錦標賽

15. Which TWO religions celebrate Diwali?

哪兩種宗教會慶祝光明節？

（A）Buddhist佛教

（B）Muslim穆斯林教

（C）Hindu印度教

（D）Sikh錫克教

16. In the 17th century, there were TWO main groups in Parliament, namely:

在17世紀，英國國會中有兩個主要團體，它們分別是：

（A）The Whigs輝格黨

（B）The Liberal Democrats自由民主黨

（C）The Tories托利黨

（D）The Conservative Party保守黨

17. Which of the following castles are located in Scotland? (Choose TWO)

下列哪個城堡是位於蘇格蘭？（選兩個）

（A）Conwy Castle康威城堡

（B）Caernarfon Castle卡那文城堡

（C）Crathes Castle克雷斯城堡

（D）Inveraray Castle因弗雷里城堡

18. Those who have not paid enough National Insurance premiums will not be able to get certain payment-type benefits, including (Choose TWO):

那些沒有支付足夠國民保險費的人，將無法獲得以下哪些利益？（選兩個）：

（A）Jobseeker's Allowance失業津貼

（B）A full state retirement pension全額政府養老金

（C）Disability Living Allowance殘疾救濟金

（D）Reading Allowance閱讀津貼

19. Which TWO of the following forts are part of Hadrian's Wall?

以下哪兩個堡壘是屬於哈德良長城的組成部分？

（A）Vindolanda文德蘭達要塞

（B）Stonehenge巨石陣

（C）Maiden特梅登

（D）Housesteads Roman Fort斯戴德羅馬堡壘

20. Which of the following TWO islands are 'Crown dependencies'?

以下哪兩個島是皇家屬地？

（A）Ceylon錫蘭

（B）The Isle of Man曼島

（C）The Channel Islands海峽群島

（D）Ireland愛爾蘭

21. In 1455, which TWO families waged a civil war to decide who should be the king of England?

 以下哪兩個家庭發動內戰，以確定誰該成為1455年的英格蘭君王？

 （A）The House of Lancaster蘭開斯特宮

 （B）The House of Kent肯特宮

 （C）The House of York約克宮

 （D）The House of Newcastle紐卡素宮

22. How can you visit the Northern Ireland Assembly (Choose TWO)?

 你可以如何前往北愛爾蘭議會（選兩個）？

 （A）Contacting the Education Service聯絡教育服務單位

 （B）Contacting an Member of the Scottish Parliament (MSP)聯絡蘇格蘭議會議員

 （C）Contacting an Mutual Legal Assistance (MLA)聯絡司法互助

 （D）Arrange tours through tourist services通過安排旅行團前往

23. In which TWO cases, the person summoned to serve as a juror may be exempted?

 在下列哪兩種情況下，被傳召出任陪審員的人可以獲得豁免？

 （A）If they have a criminal conviction如果他們有刑事定罪

 （B）If they have children如果他們有孩子

 （C）If they are forgiven for good reasons, such as physical discomfort如果出於可被原諒的理由（如身體不適）

 （D）If they have to go to work如果他們有工作要上班

24. How can you visit the Parliament (Choose TWO)?

您可以如何到訪英國議會（選兩個）？

（A）Arranging a tour through the visitor services通過遊客服務，如舉辦旅行團

（B）Write to your local MP toask for tickets寫信給國會議員

（C）Queueing on the day at the public entrance在議會舉行當天，於公共入口排隊

（D）Contacting an MSP聯絡蘇格蘭議員

25. What TWO words originate from Viking language?

哪兩個英文字是由維京語演變出來？

（A）Grimsby大格里姆斯比

（B）Scunthorpe斯肯索普

（C）Thunderstorm雷暴

（D）Butterfly蝴蝶

26. Which TWO of the following are traditional British foods?

以下哪些是英國的傳統食品？（選兩個）

（A）Roast Beef烤牛肉

（B）Green curry青咖哩

（C）Pasta carbonara卡邦尼意粉

（D）Fish and Chips炸魚薯條

27. How do local authorities get funding (Choose TWO)?

 地方當局從哪裡獲得資金（選兩個）？

 （A）The Queen英女王

 （B）The Central government中央政府

 （C）Donations from local residents當地居民的捐款

 （D）Local taxes地方稅

28. Which TWO wives of Henry VIII were accused of bringing a lover and executed?

 亨利八世哪兩位妻子被指控帶情人並被處決？

 （A）Anne of Cleves克里維斯的安妮

 （B）Catherine Howard嘉芙蓮·霍華德

 （C）Catherine Parr凱瑟琳·帕爾

 （D）Anne Boleyn安妮·博林

29. Which TWO scientists successfully cloned the first mammalian sheep Dolly?

 以下哪兩位科學家，成功複製了叫「多莉」的全球第一隻哺乳動物---綿羊？

 （A）Sir Frank Whittle弗蘭克·惠特爾爵士

 （B）Sir Robert Edwards羅伯特·愛德華茲爵士

 （C）Sir Ian Wilmot伊恩·威爾莫特爵士

 （D）Keith Campbell基思·坎貝爾

30. **Which of the following soap operas is the most popular in the UK? (Choose TWO)**

以下哪些肥皂劇在英國大受歡迎？（選兩個）

（A）Braveheart

（B）Coronation Street

（C）EastEnders

（D）Heroes

31. **TWO names are given to the day before Lent:**

四旬期前一天另有哪兩個名字？

（A）Pancake day鬆餅節

（B）Domesday末日審判

（C）Shrove Tuesday懺悔星期二

（D）Ash Wednesday聖灰星期三

32. **What TWO houses were confronted during the Wars of the Roses?**

玫瑰戰爭期間有哪兩個敵對陣營？

（A）The House of Lancaster蘭開斯特宮

（B）The House of Leicester萊斯特宮

（C）The House of Canterbury坎特伯雷宮

（D）The House of York約克宮

33. Which TWO of the following are the basic principles of life in the UK?

以下哪兩項是英國生活的基本原則？

（A）Tolerance towards people of different beliefs對不同信仰的人的包容

（B）Buy food from local businesses從當地企業購買食物

（C）Rule of Law法治

（D）Doing the military service服兵役

34. Every year, which TWO universities compete with each other in the river Thames rowing competition?

哪兩家大學每年在泰晤士河划船比賽中互相競爭？

（A）University College of London倫敦大學學院

（B）Imperial College倫敦帝國學院

（C）Cambridge University劍橋大學

（D）Oxford University牛津大學

35. How can you get the contact information of all representatives and their parties (Choose TWO)?

你可以從哪裡獲得所有政黨代表及聯絡方式（選兩個）？

（A）Bookstores書店

（B）Market市集

（C）Library圖書館

（D）website互聯網

36. Which TWO islands are closely connected to the United Kingdom, but not part of the United Kingdom?

哪兩個島嶼與英國緊密相連，但不屬於英國？

（A）The Isle of Man曼島

（B）Malta馬爾他

（C）The Channel Islands海峽群島

（D）Fiji斐濟

37. What does the British government offer to her residents or citizens (choose TWO)?

英國向其居民或公民提供什麼（選兩個）？

（A）Freedom of belief and religion, Freedom of speech信仰自由、宗教信仰、言論自由

（B）Free university tuition fees, Freedom from unfair discrimination 大學免學費、不受不公正的歧視

（C）A right to a fair trial, right to join in the election of a government 公正審判權、參加政府選舉的權利

（D）All of abover以上皆是

38. What can you donate that may help others who are injured or ill-nesses (choose TWO)?

你可以通過捐贈什麼來幫助受傷或患病的人（選兩個）？

（A）Blood血、

（B）Saliva唾液

（C）Kidney腎

（D）Liver肝

39. **Which TWO were great thinkers of the Enlightenment?**

啟蒙運動的兩位偉大思想家是哪兩位？

（A）Robert Burns

（B）Robert Louis Stevenson

（C）Adam Smith

（D）David Hume

40. **Regarding the Magistrates and Justices of the Peace (JPs) in England, Wales and Scotland, which TWO of the following statements are true?**

關於英格蘭、威爾士和蘇格蘭的審判官和太平紳士的描述，以下哪兩項屬正確？

（A）They are paid審判官和太平紳士都是有償工作

（B）They do not need legal qualifications審判官和太平紳士並不需要法律資格

（C）They have legal qualifications審判官和太平紳士均具備法律資格

（D）They usually work for free審判官和太平紳士通常都是免費工作

41. **In Scotland, which TWO of the following days are public holidays?**

下面哪兩個日子是蘇格蘭的公眾假期？

（A）December 24十二月二十四日

（B）January 1一月一日

（C）January 2一月二日

（D）January 3一月三日

42, **Where is the London Eye? (Choose TWO)**

倫敦眼在哪裡？（選兩個）

（A）North bank北岸

（B）Lihe River漓江

（C）South bank南岸

（D）the Thames泰晤士河

43. **When does Lent take place?**

四旬節是指：（選兩個）

（A）40 days before Easter復活節前四十天

（B）Also known as 'Good Friday' 又稱作Good Friday

（C）30 days before Christmas聖誕節前三十天

（D）Also known as 'Quadragesima' 又稱作大齋期

44. **When did the Wars of the Roses start and end?**

玫瑰戰爭何時開始？又於何年結束？

（A）1455

（B）1460

（C）1470

（D）1485

45. **How can one facing domestic violence can find a safe place to stay? (Choose TWO)**

當面對家庭暴力，如何找到一個安全的地方？（選兩個）

（A）Going to hotel far from home去遠離居所的旅館

（B）Contacting the National Domestic Violence Free phone Helpline
致電全國家暴求助熱線求助

（C）Call police聯絡警察

（D）Go to hospital到醫院

46. **The longer life expectancy in the UK will affect: (Choose TWO)**

英國人的預期壽命越長，越會對以下哪兩項有影響？（選兩個）

（A）Number of homeless無家可歸者的人數

（B）Food shortage糧食短缺

（C）Pension expenses養老金開支

（D）Health expense政府用於健康的經費

47. **Which of the following are Bank Holidays of Britain and Scotland (Choose TWO)?**

以下哪些是英格蘭及威爾斯地區的銀行假期（選兩個）？

（A）New Year's Day新年

（B）Good Friday聖週五

（C）Labour Day勞動節

（D）Remembrance Day停戰日

48. There are TWO different types of rugby in the UK:

英國有以下哪兩種不同類型的欖球？

（A）Union聯合式欖球

（B）League聯盟式欖球

（C）Rugby Open欖球公開賽

（D）Free style花式欖球

49. In the 1960s, which TWO popular music groups became popular?

在1960年代，哪兩個流行樂隊組合開始流行？

（A）Air Supply空中補給

（B）The Rolling Stones滾石樂隊

（C）The Beatles披頭四

（D）Chemical Brothers化學兄弟

50. Which TWO British kings believed in the 'Divine Right of Kings'?

哪兩位英國國王信奉「皇權神授」的說法？

（A）Richard I理查德一世

（B）James I占士一世

（C）Charles I查理一世

（D）Henry V亨利五世

51. Why recycling is so important? (Choose TWO)

為什麼廢物回收這樣重要？（選兩個）

（A）Using recycled materials to make new products consumes less energy than using raw materials.使用再生材料製造新產品比使用原材料消耗更少的能源。

（B）This is a criminal offense, and if you don't, you may be arrested.這是刑事犯罪，如果您不這樣做，則可能會被捕。

（C）Reduce the expenses of local councils減少地方議會的開支

（D）Less garbage is generated, so the amount of landfill is reduced 產生的垃圾較少，因此垃圾填埋量減少了。

Answer:
答案及解析：

1. B and C

The National Trust and Friends of the Earth are environmental charities.

只有國家信託（National Trust）和地球之友（Friends of the Earth）是保護環境的慈善機構。（按：Environmental Working Group（EWG）是美國環保組織，而PDSA（People's Dispensary for Sick Animals）則為英國一所獸醫慈善機構。）

2. B and C

To apply to become a permanent resident or citizen of the UK, you need to speak and read English and have a good understanding of life in the UK.

要申請成為英國的永久居民或公民，您需要掌握一定的英語能力，並對英國的生活有一定程度的了解。

3. B and C

NATO is a group of European and North American countries that agree to help each other in the event of an attack. It also aims to maintain peace among all its members.

北約是一群歐洲和北美國家，它們同意在發生襲擊時互相幫助。它還旨在維護其所有成員之間的和平。

4. B and C

Sailing continues to be popular in the UK, reflecting its maritime heritage. Boating is also very popular, as both a leisure activity and a competitive sport.

帆船運動在英國仍然很受歡迎，反映出其文化遺產。賽艇也很受歡迎，既是休閒活動，又是一項競技比賽項目。

5. A and C

The UK continues to maintain a particularly strong position in special effects and animated films

英國在特技效果電影和動畫電影方面繼續保持強勢的地位。

6. B and C

Charities that work with the homeless include crisis and shelters.

與無家可歸者合作的慈善機構包括危機和庇護所。Shelter是一個房屋慈善機構，至於Crisis（危機慈善機構）是幫助英國上萬名無家可歸者的街頭露宿者。

7. A and C

You can contact MPs by letter or phone in their constituency office or in the office of the House of Commons in the House of Commons: House of Commons, Westminster, London, SW1A OAA, London, telephone 0207729 3000.

您可以在國會議員的選區辦公室或下議院的辦公室中，以信函或電話聯絡國會議員。

8. B and C

To obtain a UK driving license, you must pass a driving test, which will test your knowledge and practical skills.

要獲得英國駕駛執照，您必須通過駕駛考試，該考試將測試您的知識和實踐技能。

9. A and C

David Lean directed "Brief Encounter" (1945) and "Lawrence of Arabia" (1962).

大衛·利恩（David Lean）執導過《Brief Encounter》（1945）和《Lawrence of Arabia》（1962）。

10. C and D

Britain and France developed the world's only supersonic commercial airliner, the Concorde.

英國和法國研製了世界上唯一的超音速商業客機：和諧式客機。

11. A and C

Respect and abide by the law, take care of the area and environment where you live, this is the correct answer.

尊重並遵守法律、照顧好您居住的地區和環境，這是正確的答案。

12. A and B

In the "Swinging Sixties", the abortion and divorce laws were relaxed.

在「搖擺倫敦」期間，英國政府放寬了墮胎法和離婚法。

13. C and D

After the Norman conquest, the king and his nobles spoke Norman French, and the farmers continued to speak Anglo-Saxon. The two languages gradually merged into one English.

在征服諾曼第後，英國國王和他的貴族講諾曼法語，農民們繼續講盎格魯撒克遜語，兩種語言後來逐漸合併為英語。

14. B and C

Famous British horse racing events include the Royal Ascot and the Grand National.

英國著名的賽馬活動包括Royal Ascot和The Grand National。

15. C and D

Hindus and Sikhs celebrate Diwali. It usually lasts five days in October or November. It is often called the Festival of Lights.

印度教徒和錫克教徒慶祝光明節。通常在十月或十一月持續五天。它通常又被稱為「排燈節」。

16. B and C

In the 17th century, there were two main groups in Congress, the Whig Party and the Conservative Party.

在17世紀，英國國會中有兩個主要團體：輝格黨和保守黨。

17. C and D

Inveraray Castle and Crathes Castle are located in Scotland.

因弗雷里城堡和克雷斯城堡都是位於蘇格蘭。

18. A and B

Anyone who does not pay enough National Insurance payments will not be able to receive certain contributory benefits, such as the Jobseeker Allowance or statewide pension.

任何未支付足夠國民保險費（National Insurance）的人，將無法獲得某些繳費型福利，例如失業津貼（JSA）或全額政府養老金（A full state retirement pension）。

19. A and D

Part of Hadrian's Wall includes the fortresses of Housesteads and Vindolanda.

哈德良長城的一部分包括斯戴德羅馬堡壘（Housesteads）和文德蘭達要塞（Vindolanda）。

20. B and C

There are several islands that are closely connected to but not part of Britain: the Channel Islands and the Isle of Man. They have their own government, called "Crown Dependence".

有幾個與英國緊密相連但不屬於英國的島嶼：海峽群島和馬恩島。他們有自己的政府，稱為「皇冠依賴」（Crown dependencies）。

21. A and C

In 1455, a civil war began to decide who should become the king of England. It was carried out between supporters of two families: Lancaster Palace and York Palace.

1455年，兩個家庭的支持者開展了一場內戰，以決定誰成為英格蘭國王，該兩個家庭分別是：蘭開斯特宮和約克宮。

22. A and C

There are two ways to arrange a visit to the Stormont Northern Ireland Conference. You can contact the Education Service (detailed information is on the Northern Ireland Assembly website http://www.niassembly.gov.uk) or contact MLA.

如欲訪問北愛爾蘭會議，有兩種方式：第一，您可以聯絡教育服務單位；第二，聯絡司法互助。

23. A and C

Everyone called to serve as a juror must do so unless they are ineligible (for example, because they have a criminal conviction) or they have a good reason for removal, such as being unwell.

每個被要求擔任陪審員的人都必須這樣做，除非他們沒有資格（例如有刑事罪行）或者他們有充分的理由被遣散，如身體不適。

24. B and C

To visit the British Parliament, you can write to local MPs in advance to ask for tickets, or you can line up at the public entrance on the same day.

要訪問英國議會，您可以提前寫信給當地國會議員索取門票，也可以在議會舉行當天，於公共入口排隊。

25. A and B

Many Viking invaders stayed in the UK-especially in the Danelaw area in the east and north of England (many place names there, such as Grimsby and Scunthorpe, come from the Viking language).

許多維京入侵者留在英國，特別是在英格蘭東部和北部的丹尼勞地區（那裡的許多地名，例如Grimsby和Scunthorpe，都是來自維京人的語言）。

26. A and D

Roast beef and fish and chips are traditional British foods.

烤牛肉和炸魚薯條都是英國的傳統食品。

27. B and D

Local authorities provide a range of services in their area. They are funded by central government funds and local taxes.

地方當局會在其所在地區提供一系列服務，而它們是由中央政府資金和地方稅收資助。

28. B and D

Anne Boleyn and Catherine Howard were both accused of bringing a lover and executed

安妮·博林和嘉芙蓮·霍華德皆被指控帶情人並被處決。

29. C and D

In 1996, two British scientists, Sir Ian Wilmot and Keith Campbell, led a research team, which was the first successful complex mammalian Dolly sheep.

1996年，兩位英國科學家Ian Wilmot爵士和Keith Campbell領導了一個研究小組，這是第一個成功複雜哺乳動物多莉綿羊的小組。

30. B and C

"Coronation Street" is a classic British soap opera. It is the longest-running TV series and the highest-rated series in the history of British television.

"EastEnders" is another British feature-length TV soap opera. The play began to be broadcast on the BBC (British Broadcasting Corporation) in February 1985 and has been broadcast more than 5,000 episodes.

《Coronation Street》是一部英國經典肥皂劇，該劇是英國電視史上播放時間最長的電視劇集和收視最高的的劇集。

《EastEnders》則是另一部英國長篇電視肥皂劇。該劇從1985年2月開始在BBC（英國廣播公司）播出，至今已經播出了超過5千集。

31. A and C

Lent refers to the 40-day fast before Easter, and the day before the beginning of Lent is called Shrove Tuesday or Pancake Day. As for the first day of the fasting period, it is called Ash Wednesday.

Lent（四旬期）是指復活節前的40天齋期，而四旬期開始的前一天稱為Shrove Tuesday或Pancake Day。至於在齋戒期開始的第一天稱為Ash Wednesday（聖灰星期三）。

32. A and D

The War of the Roses was fought between the supporters of two families: Lancaster Palace and York Palace.

玫瑰之戰是在兩個家族的支持者之間進行的：The House of Lancaster和The House of York。

33. A and C

Tolerance for people of different faiths and the rule of law are the basic principles of life in the UK.

對不同信仰的人的包容以及法治是英國生活的基本原則。

34. C and D

Students from Oxford and Cambridge universities compete in rowing competitions on the Thames every year.

牛津大學和劍橋大學的學生，每年都會在泰晤士河上進行划船比賽。

35. C and D

You can get the contact information of all representatives and their political parties from the library and online (search http://www.parliament.uk).

您可以從圖書館和網上（搜尋http://www.parliament.uk）獲取所有代表及其政黨的聯絡方式。

36. A and C

The Channel Islands and the Isle of Man (or the Isle of Man) are closely connected with the United Kingdom, but are not part of the United Kingdom.
海峽群島和曼島（或稱馬恩島）與英國緊密相連，但不屬於英國。

37. A and C

The British government will provide its residents or citizens: freedom of belief and religion, freedom of speech, freedom from unfair discrimination, the right to a fair trial, and the right to participate in government elections.
英國政府會向其居民或公民提供：信仰和宗教自由、言論自由、免受不公平歧視的自由、受到公正審判的權利以及參加政府選舉的權利。

38. A and C

You can help injured or sick people by donating blood and kidneys.
你可以通過捐血液和腎臟幫助受傷或患病的人。

39. C and D

Many of the great thinkers of the Enlightenment were Scottish. Adam Smith developed ideas about economics. David Hume wrote about human nature.
啟蒙運動的許多偉大思想家都是蘇格蘭人。亞當·斯密（Adam Smith）提出了有關經濟學的觀點。大衛·休ume（David Hume）寫了關於人性的文章。

40. B and D

In England, Wales and Scotland, Magistrates and Justices of the Peace (JPs) usually work without pay and do not require legal qualifications.
在英格蘭、威爾士和蘇格蘭，審判官和太平紳士通常是無薪工作，且不需要法律資格。

41. B and C

In Scotland, January 1 and January 2 are public holidays.
在蘇格蘭，1月1日和1月2日均為公眾假期。

42. C and D

Located on the south bank of the Thames, the London Eye is a ferris wheel, 443 feet (135 meters) high.

倫敦眼位於泰晤士河南岸，它是一座摩天輪，高443英尺（135米）。

43. A and D

The 40 days before Easter is called Lent. This is when Christians spend time reflecting and preparing for Easter. Lent is also called Lent.

復活節前40天稱為四旬節。這是基督徒花時間反思和準備復活節的時候，四旬節又叫大齋期。

44. A and D

The War of the Roses, a battle that lasted for about 30 years, began in 1455 and ended in 1485.

玫瑰戰爭一場維持了約30年的戰役，於1455年開始，並在1485年結束。

45. B and C

When facing domestic violence, you can always get help through the 24-hour National Domestic Violence Free phone Helpline (National Domestic Violence Free phone Helpline) 0808 2000 247, or contact the police to help you find a safe place to stay.

當面臨家庭暴力，你可以隨時通過24小時全國家暴求助熱線（National Domestic Violence Free phone Helpline）0808 2000 247獲得幫助，或者聯絡警方助你找到安全的地方暫住。

46. C and D

British people live longer than ever before. This is due to the improvement of living standards and better medical services. There is now a record number of people aged 85 and over. This will affect pension and medical expenses.

英國人的壽命比以往任何時候都長。這是由於生活水平的提高和更好的醫療服務。現在有創紀錄的85歲及以上的人數。這將影響養老金和醫療開支。

47. A and B

New Year's Day (New Year's Day) and Good Friday (Holy Friday) are bank holidays in England and Wales. As for Labor Day (Labor Day) and Remembrance Day (Arse Day) are holidays in the United States and France respectively.

New Year's Day（新年）和Good Friday（聖週五）是英格蘭及威爾士地區的銀行假期。至於Labour Day（勞動節）和Remembrance Day（停戰日）分別是美國和法國的假期。

48. A and B

There are two different types of rugby, they have different rules: they are: Union and League.

欖球有兩種不同類型，它們有不同的規則：分別是：聯合式和聯盟式欖球。

49. B and C

The Beatles and The Rolling Stones were two famous pop music groups in the 1960s. As for Air Supply, it appeared in the mid-1970s, while Chemical Brothers was a combination that lived in the 1990s.

披頭四和滾石樂隊是1960年代兩個著名的流行音樂團體。至於Air Supply則於1970年代中期出現，而Chemical Brothers則是活囉於1990年代的組合。

50. B and C

Both James I and his son Charles I believed in the term "Divine Right of Kings" that is, the idea of the king being directly appointed by God. They believe that the king can take action without the approval of Parliament.

占士一世和他的兒子查理一世都信奉「皇權神授」的說法，即國王直接由上帝任命的統治思想。他們認為，國王無需國會批准，即可採取行動。

51. A and D

Recycling as much waste as possible is very important. Using recycled materials to make new products consumes less energy, which means we don't need to extract more raw materials from the earth. This also means less waste generation, and there

fore fewer landfill sites.

回收盡可能多的廢物非常重要。使用再生材料製造新產品消耗的能源更少，這意味著我們不需要從地球上提取更多的原材料。這也意味著減少了廢物的產生，因此減少了垃圾掩埋場的數量。

PART THREE
模擬試卷

MOCK EXAM

MOCK PAPER 1

The test consists of 24 questions, and you need to answer at least 18 correctly to pass.

1. **When is April Fool' s Day?**

 （A）April 1

 （B）April 13

 （C）April 30

 （D）April 5

2. **Where is the city of Bradford located in?**

 （A）England

 （B）Scotland

 （C）Wales

 （D）Northern Ireland

3. **Which flag contains a red cross on a white background?**

 （A）The cross of St Andrew, patron saint of Scotland

 （B）The cross of St David, patron saint of Wales

 （C）The cross of St Patrick, patron saint of Ireland

 （D）The cross of St George, patron saint of England

4. **When did the first farmers arrive in the United Kingdom?**

 （A）6,000 years ago

 （B）7,000 years ago

 （C）8,000 years ago

 （D）10,000 years ago

5. **In which British county is the Stonehenge monument located?**

 (A) Bedfordshire

 (B) Cheshire

 (C) Wiltshire

 (D) Cornwall

6. **What is the most famous work of Robert Burns?**

 (A) Auld Lang Syne

 (B) Hamlet

 (C) A rose by another name

 (D) George's Marvellous Medicine

7. **The cross of St David,patron saint of Wales does not belong to the Union flag.**

 (A) True

 (B) False

8. **November 30 is halloween celebrated.**

 (A) True

 (B) False

9. **Bradley Wiggins is the first British long-distance runner to win a gold medal at the 10,000m Olympics.**

 (A) True

 (B) False

10. A relaxing show with music and comedy based on fairy tales enjoyed by family audiences is called Pantomimes.

　(A) True

　(B) False

11. British actor Joseph Turneris famous for his role in Shakespeare's plays.

　(A) True

　(B) False

12. William the Conqueror built the Tower of London after becoming king in 1066.

　(A) True

　(B) False

13. Which of the following statements is CORRECT?

　(A) The Treaty of Rome signed in March 25, 1957

　(B) The Treaty of Rome signed in May 25, 1957

14. Which of the following statements is CORRECT?

　(A) Gustav Holst composed a suite of pieces themed around the planets and the solar system called 'The Planets'.

　(B) The Edward Elgar composed a suite of pieces themed around the planets and the solar system called 'The Planets'.

15. Which of the following statements is CORRECT?

(A) The population of the UK in 2019 is 66.65 million.

(B) The population of the UK in 2019 is 65.56 million.

16. Which of the following statements is CORRECT?

(A) The Prime Minister is the Speaker is the chief officer of the House of Commons.

(B) The Speaker is the chief officer of the House of Commons.

17. Which of the following statements is CORRECT?

(A) The characteristics of the British Constitution is: not recorded in any single document, so it is described as "unwritten.

(B) The characteristics of the British Constitution is: written by the Prime Minister.

18. Which of the following statements is CORRECT?

(A) Queen Victoria when she became Queen in 1837 when she was 18 years old.

(B) Queen Victoria when she became Queen in 1837 when she was 8 years old.

19. When did the First World War begin and end in? (Choose TWO)

(A) 1912

(B) 1914

(C) 1916

(D) 1918

20. Popular social networking tools in the UK include: (Choose TWO)

（A）Drupal

（B）Facebook

（C）Weibo

（D）Twitter

21. Which of the followings come from the Anglo-Saxon language?(Choose TWO)

（A）Apple

（B）Music

（C）Grimsby

（D）Summer

22. Which of the following areas does the Welsh Assembly have the power to make laws ? (Choose TWO)

（A）Education and training

（B）Military defence

（C）Immigration

（D）Housing

23. Most citizens of the United Kingdom, the Irish republic or the Commonwealth aged 18 or above can stand for public office, except for (Choose TWO):

（A）People convicted of certain criminal offences

（B）People without a university degree

（C）Members of the Armed Forces

（D）All of the above

24. The opposition leader leads his party to point out their view of the government' s position (Choose TWO):

（A）Failures

（B）Achievements

（C）Strengths

（D）Weaknesses

END OF THE TEST

Answer (Paper 1):
答案及解析：

1. A

April Fool's Day is April 1.
愚人節是4月1日。

2. A

Bradford is located in England.
巴拉福特德位於英格蘭。

3. D

England's patron saint George's cross is the Red Cross on a white background.
聖喬治的十字架是白色背景上的紅十字會。

4. A

Since 6000 years ago, the first farmers came to Britain.
第一批農民在6000年前到英國。

5. C

The ancestors of the first farmers was from Southeast Europe. These people built houses, monuments and tombs on the land. One of these monuments, Stonehenge still stands in what is now Wiltshire, England.
第一批農民的祖先可能來自東南歐。這些人在土地上建造房屋，陵墓和紀念碑。這些紀念碑之一，巨石陣仍然屹立在現在的英格蘭威爾特郡。

6. A

Robert Burns's most famous work is probably the song "Auld Lang Syne", a song sung by people in the United Kingdom and other countries to celebrate the New Year (or Hogmanay as it is called in Scotland).
羅拔彭斯最著名的作品可能是歌曲《友誼萬歲》，這是英國和其他國家/地區的人為慶祝新年（或蘇格蘭的Hogmanay）時演唱的歌曲。

7. A

The cross of David, the patron saint of Wales, does not belong to the Union flag, because when the first Union flag was created from the flags of Scotland and England in 1606, the Principality of Wales was already tied with England.

威爾斯的守護神大衛的十字架不屬於聯盟旗幟，因為當1606年根據蘇格蘭和英格蘭的旗幟創建了第一個聯盟旗幟時，威爾斯公國已經與英格蘭並列。

8. B

Halloween is celebrated on October 31.

10月31日慶祝萬聖節。

9. B

Mo Farah (1983-) is a British long-distance runner who was born in Somalia. He won gold medals in the 5,000 metres and 10,000 metres Olympics in 2012, and was the first British to win an Olympic gold medal within 10,000 metres.

Mo Farah（1983-）是出生於索馬里的英國長跑運動員。2012年，他奪得5千米和10,000米奧運會金牌，並且是第一位在10,000米內獲得奧運金牌的英國人。

10. A

Many theaters make pantomimes during Christmas. Based on fairy tales, they are light musicals with music and comedy, and are popular with family audiences.

在聖誕節期間，許多劇院都製作默劇。根據童話故事，它們是帶有音樂和喜劇的輕音樂劇，並受到家庭觀眾的歡迎。

11. A

The Lawrence Olivier Prize is held every year in different locations in London. There are various categories, including best director, best actor and best actress. The award is named after the British actor Sir Laurence Olivier, the late Lord Olivier, who is known for his roles in various Shakespearean plays.

勞倫斯·奧利維爾獎每年在倫敦的不同地方舉行。有各種類別,包括最佳導演,最佳男演員和最佳女演員。該獎項以英國演員勞倫斯·奧利維爾爵士(Sir Laurence Olivier),已故的奧利維爾勳爵(Lord Olivier)命名,他以在莎士比亞戲劇中的角色而聞名。

12. A

The Tower of London was first built by William the Conqueror after he became king in 1066.

倫敦塔由征服者威廉於1066年當成為國王之後建造。

13. A

The European Union (EU), formerly known as the European Economic Community (EEC), was established by six Western European countries (France, Belgium, Italy, Germany, the Netherlands and Luxembourg), and signed the Treaty of Rome on March 25, 1957.

歐盟(EU)由六個西歐國家(法國、比利時,意大利、德國、荷蘭和盧森堡)成立,前身為歐洲經濟共同體(EEC),並於1957年3月25日簽署了《羅馬條約》。

14. A

Important British composers include Gustav Holst, his works include "The Planets", this set of works around planets and the solar system.

英國重要的作曲家包括霍爾斯特(Gustav　　Holst),他的作品包括《行星》(The Planets),這組圍繞行星和太陽系的作品。

15. A

The population of Britain in 1998 was 66.65 million.

2019年英國的人口為6,665萬。

16. B

The debate in the House of Commons is presided over by the Speaker. This person is the chief official of the House of Commons.

下議院的辯論由議長主持。此人是下議院的首席官員。

17. A

The British constitution is not written down in any single document. Therefore it is described as 'unwritten'.

英國憲法沒有寫在任何單一文件中，因此被描述為「未成文」。

18. A

In 1837, Queen Victoria became Queen of the United Kingdom of Great Britain and Ireland at the age of 18.

1837年，維多利亞女王在18歲時成為英格蘭女王。

19. B and D

On 28th June, 1914, Archduke Ferdinand of Austria was assassinated, which triggered a series of events that led to the First World War (1914-18).

在1914年6月28日，奧地利大公斐迪南被暗殺，引發了導致第一次世界大戰（1914-18）的一系列事件。

20. B and D

Social networking websites such asFacebook and Twitterare a popular in the UK.

諸如Facebook和Twitter之類的社交網站在英國非常受歡迎。

21. A and D
The words 'Apple' and 'summer' are based on Anglo-Saxon language.
單詞 Apple和summer是基於盎格魯-撒克遜語。

22. A and D
The Welsh Assembly has the power to make laws in 20 areas, including: education and training, health and social services, economic development and housing.
威爾斯議會有權在20個領域制定法律，包括：教育和培訓、衛生和社會服務、經濟發展和住房。

23. A and C
Members of the Commonwealth who are 18 years of age or above can stand for public office. However, there are some exceptions, including: members of the armed forces, civil servants and people convicted of certain criminal offences.
年滿18歲的英聯邦成員可以擔任公職。有一些例外，包括：武裝部隊成員，公務員和因某些刑事罪行被定罪的人。

24. A and D
Opposition leader leads his party to point out what they believe is the government's failures and weaknesses.
反對黨領導人帶領黨派指出他們認為是政府的失敗和弱點。

MOCK PAPER 2

The test consists of 24 questions, and you need to answer at least 18 correctly to pass.

1. **If an MP dies or resigns, a new election will be held, namely:**

 （A）Hansard

 （B）First past the post

 （C）By-election

 （D）Coalition

2. **What was the name of the period of rapid development of British industry in the 18th and 19th centuries?**

 （A）Enlightenment

 （B）Industrial Revolution

 （C）Victorian era

 （D）Interwar period

3. **Who was responsible for the construction of the Great Western Railway?**

 （A）Isambard Kingdom Brunel

 （B）Sir Norman Foster

 （C）Sir Christopher Wren

 （D）Robert Adam

4. **How many members does the UN Security Council have?**

 （A）5

 （B）10

 （C）15

 （D）25

5. **Why did Elizabeth I imprison her cousin Mary for 20 years?**

 (A) She disagrees with her political views

 (B) She suspects that Mary wants to take over the British throne

 (C) She killed her son

 (D) She is a spy for the Spanish fleet

6. **What was the name of the first cloned mammal?**

 (A) Molly

 (B) Dolly

 (C) Colin

 (D) Alice

7. **The Council of Europe is responsible for the creation of the European Convention on Human Rights and Fundamental Freedom.**

 (A) True

 (B) False

8. **Harold Macmillan became Prime Minister of the UK in May 1940?**

 (A) True

 (B) False

9. **At the 'Eden Project', you can find giant greenhouses, house plants from all over the world.**

 (A) True

 (B) False

10. Custard pies is a traditional Scottish food.

（A）True

（B）False

11. The Laurence Olivier Awards take place annually.

（A）True

（B）False

12. 14th of February is Valentine's Day.

（A）True

（B）False

13. Which of the following statements is CORRECT?

（A）17th of March is St Patrick's Day, patron to of Northern Ireland.

（B）11th of March is St Patrick's Day, patron to of Northern Ireland.

14. Which of the following statements is CORRECT?

（A）The term 'PDSA' stand for Pilot Program for Sustainable Agriculture

（B）The term 'PDSA' stand for People's Dispensary for Sick Animals

15. Which of the following statements is CORRECT?

（A）English settlers begin to colonise the eastern coast of America during Elizabeth I's time

（B）English settlers begin to colonise the eastern coast of America during Henry VIII's time

16. Which of the following statements is CORRECT?

（A）The Black Death come to England in 1348.

（B）The Black Death come to England in 1248.

17. Which of the following statements is CORRECT?

（A）The name of the annual event that gives awards in a range of musical categories, such as best British group and best British solo artist is: The Brit Awards.

（B）The name of the annual event that gives awards in a range of musical categories, such as best British group and best British solo artist is: The Mercury Music Prize

18. Which of the following statements is CORRECT?

（A）The name given to the elected members of the Welsh Assembly is: AMs.

（B）The name given to the elected members of the Welsh Assembly is: MPs.

19. **What are the two other names of the Church of England? (Choose TWO)**

 (A) The Anglican Church

 (B) The Union Church

 (C) The Greatest Church

 (D) The Episcopal Church

20. **Which TWO are Protestant Christian groups in the UK? (Choose TWO)**

 (A) Baptists

 (B) Methodists

 (C) Roman Catholics

 (D) Buddhists

21. **What are TWO fundamental principles of British life? (Choose TWO)**

 (A) Only driving your car on weekdays

 (B) Participation in community life

 (C) Growing your own fruit and vegetables

 (D) Tolerance of those with different faiths and beliefs

22. There are _____ _____ countries are members of the United Nations. (Choose TWO)

 (A) More than
 (B) Just
 (C) 190 countries
 (D) 390 countries

23. Which 2 types of literature is William Shakespeare famous for? (Choose TWO)

A. Novels

B. Plays

C. Biographies

D. Sonnets

24. _____ _____ British casualties were recorded during the First World War. (Choose the nearest figure)

 (A) More than
 (B) Less than
 (C) 2 million
 (D) 5 million

END OF THE TEST

Answer (Paper 2):
答案及解析：

1. C

If a member of Parliament dies or resigns, a new election will be held in his or her district, called a 'by-election;.

如果國會議員去世或辭職，新的選舉將在其所在地區舉行，稱為補選。

2. B

The Industrial Revolution was the rapid development of industry in Britain in the 18th and 19th centuries.

工業革命是指18世紀和19世紀的英國工業得到快速發展。

3. A

Isambard Kingdom Brunel was responsible for the construction of the Great Western Railway, which was the first major railway built in the UK.

Isambard Kingdom Brunel負責大西部鐵路的建設，這是英國建造的第一條主要鐵路。

4. C

The UN Security Council has 15 members and recommends action when there are international crises and threats to peace.

聯合國安理會有15個成員，並建議在發生國際危機和和平威脅時採取行動。

5. B

Elizabeth suspected that Mary wanted to inherit the British throne and imprisoned her for 20 years.

伊莉莎白懷疑瑪麗想繼承英國王位，並把她監禁了20年。

6. B

In 1996, two British scientists, Keith Campbell and Sir Ian Wilmot, led a team, which was the first to successfully clone the mammalian Dolly sheep.

1996年，兩位英國科學家Keith　Campbell和領導Ian　Wilmot爵士了一個研究小組，這是第一個成功克隆哺乳動物多莉綿羊的小組。

7. A

The Council of Europe has no power to make laws, but it has drafted conventions and charters, the most famous of which is the European Convention on Human Rights and Fundamental Freedoms.

歐洲委員會無權制定法律，但它起草了公約和章程，其中最著名的是《歐洲人權與基本自由公約》。

8. B

Churchill is the son of a politician. He was a soldier and journalist before becoming a Conservative Party MP in 1900. In May 1940, he became Prime Minister.

邱吉爾是一位政治家的兒子。在1900年成為保守黨議員之前，他曾是士兵和新聞工作者。1940年，他出任總理。

9. A

The Eden Project is located in Cornwall in southwest England. Its biome is like a huge greenhouse, containing plants from all over the world. The Eden Project is also a charity organization that carries out environmental and social projects internationally.

伊甸園項目位於英格蘭西南部的康沃爾郡。它的生物群落就像一個巨大的溫室，裡面有來自世界各地的植物。伊甸園項目也是一個慈善組織，在國際上開展環境和社會項目。

10. B

Haggis (a lamb stomach stuffed with offal, mutton, onion and oatmeal) is a traditional Scottish food.

羊雜羊雜碎、羊肉、洋蔥和燕麥塞入羊雜胃，是蘇格蘭的傳統食品。

11. A

The Lawrence Olivier Prize is held every year in different locations in London.

勞倫斯·奧利維爾獎每年在倫敦的不同地方舉行。

12. A

February 14th is Valentine's Day.

2月14日是情人節。

13. A

March 17th is St. Patrick's Day, the patron of Northern Ireland.

3月17日是北愛爾蘭的讚助人聖帕特里克節。

14. B

'PDSA' stands for People's Dispensary for Sick Animals.

「PDSA」全名是People's Dispensary for Sick Animals。

15. A

In Elizabeth I's time, British immigrants first began to colonize the East Coast of the United States.

在伊莉莎白管治時代，英國移民首先開始殖民美國的東海岸。

16. A

In 1348, a disease that might be a plague spread to England. This is the so-called Black Death.

1348年，可能是一場瘟疫的疾病傳播到了英格蘭。這就是所謂的「黑死病」。

17. A

The Brit Awards is an annual event, offering awards in various categories, such as Best British Band and Best British Solo Artist.

英國音樂獎是一項年度活動，提供各種類別的獎項，例如最佳英國樂隊和最佳英國獨奏藝術家。

18. A

In Wales the elected members are known as AMs or Assembly Members.
在威爾斯，民選成員稱為AM或理事會成員。

19. A and D

The official Church of the state is the Church of England (called the Anglican Church in other countries and the Episcopal Church in Scotland and the United States).
英國聖公會；英格蘭教會的官方教堂是英格蘭教堂（在其他國家稱為英國國教教堂，在蘇格蘭和美國則稱為基督教教堂）。

20. A and B

21. B and D

The fundamental principles of British life include:
- democracy
- the rule of law
- individual liberty
- tolerance of those with different faiths and beliefs
- participation in community life
英國生活的基本原則包括：
-民主
-法治
-個人自由
-容忍具有不同信仰和信念的人
-參與社區生活

22. A and C

The United Kingdom is part of the United Nations (UN), which is an international organization with more than 190 countries. As of mid-2018, the United Nations has a total of 193 member states
英國是聯合國（UN）的一部分，聯合國是一個擁有190多個國家的國際組織。截至2018年中，聯合國共有193個會員國。

23. B and D

William Shakespeare was a famous playwright and sonnet writer. Many of William Shakespeare's works involve life, love, death, revenge, sadness, jealousy, murder, magic and mystery. He wrote the great works of the time, some of the most famous are Macbeth, Romeo and Juliet and Hamlet. It has been 400 years since his death, but there are still people all over the world celebrating his work.

Also, the Sonnets are Shakespeare's most popular works, and a few of them, such as Sonnet 18, Sonnet 116 and Sonnet 73, have become the most widely-read poems in all of English literature.

莎士比亞是著名的劇作家和十四行詩作家。他的許多作品涉及生命、愛情、死亡、復仇、悲傷、嫉妒、謀殺、魔法和神秘。他寫了當時的偉大作品，其中最著名的有麥克白、羅密歐與朱麗葉和哈姆雷特。自他去世以來已有400年，但全世界仍然有人在研讀他的作品。

另外，「十四行詩」是莎士比亞最受歡迎的作品，例如十四行詩、十四行詩116和十四行詩73，這些已經成為所有英語文學中閱讀最廣泛的詩歌。

24. A and C

During the First World War, millions of people were killed or injured, and there were more than 2 million casualties in Britain.

第一次世界大戰期間，數百萬人被殺或受傷，英國有200萬以上的人員傷亡。

MOCK PAPER 3

The test consists of 24 questions, and you need to answer at least 18 correctly to pass.

模擬試卷 **PART THREE** MOCK EXAM

1. Why did Henry VIII decide to divorce Catherine of Aragon?

（A）She is not welcome in the country

（B）She is too old to give him another child

（C）For political reasons

（D）She was accused of taking her lover to the palace

2. How many local authorities can you find in London?

（A）22

（B）25

（C）33

（D）43

3. In which year did British combat troops leave Iraq?

（A）2004

（B）2005

（C）2006

（D）2009

4. Where does the Parliament of the UK locate in?

（A）Manchester

（B）Westminster

（C）Windsor Castle

（D）Buckingham Palace

167

5. **Which of the following is a criminal offence?**

 (A) Selling tobacco to someone under the age of 18.

 (B) Owing money to someone

 (C) Discrimination in the workplace

 (D) Selling faulty goods or services

6. **Who used a system of land ownership which is also known as "Feudalism"?**

 (A) The Greeks

 (B) The Vikings

 (C) The Normans

 (D) The Welsh

7. **'All the world's a stage' are lines from William Shakespeare's play 《Hamlet》.**

 (A) True

 (B) False

8. **During the times of Elizabeth I, English settlers began to colonise the western coast of Australia.**

 (A) True

 (B) False

9. In Wales the elected members, known as AMs, meet in the Welsh Assembly in the Senedd in Swansea.

（A）True

（B）False

10. Architectural style "Corinthian" became popular in the 19th century.

（A）True

（B）False

11. Mount Stewart garden is NOT located in England.

（A）True

（B）False

12. Oliver Cromwell was in charge of the British fleet at the Battle of Trafalgar.

（A）True

（B）False

13. Which of the following statements is CORRECT?

（A）The Sheriff Court deals with serious criminal offences in Northern Ireland.

（B）The Crown Court deals with serious criminal offences in Northern Ireland.

14. Which of the following statements is CORRECT?

（A）The Scottish Parliament formed in 1999.

（B）The Scottish Parliament formed in 2000.

15. Which of the following statements is CORRECT?

（A）People lived in roundhouses and buried their dead in tombs in Bronze Age.

（B）People were farmers who lived in large villages in Bronze Age.

16. Which of the following statements is CORRECT?

（A）Elected members of the Scottish Parliament are known as Members of the Scottish Parliament (MSPs).

（B）Elected members of the Scottish Parliament are known as Members of the Scottish Paramounts (MPs).

17. Which of the following statements is CORRECT?

（A）People usually play Hide and Seek at Halloween.

（B）People usually play Trick or treat at Halloween.

18. Which of the following statements is CORRECT?

（A）The public can listen to debates in the Palace of Westminster from public galleries located in both, the House of Commons and House of Lords.

（B）The public can listen to debates in the Palace of Westminster from public galleries located in the House of Lords.

19. Which TWO of the followings are 20th-century British discoveries or inventions?

（A）Television

（B）World wide Web

（C）Mobile phone

（D）Diesel engine

20. Which of the following persons are famous Paralympians? (Choose TWO)

（A）Jessica Ennis

（B）Ellie Simmonds

（C）Baroness Tanni Grey-Thompson

（D）Dame Ellen MacArthur

21. Which TWO members of a family have a special day dedicated to them? (Choose TWO)

（A）Uncles

（B）Fathers

（C）Mothers

（D）Aunts

22. Which TWO responsibilities should you respect as a resident of the UK?

(A) Respect and obey the law

(B) Treat others with fairness

(C) Vote for the government in power

(D) Take in and look after stray animals

23. Which TWO points about slavery are correct?

(A) William Wilberforce was a leading abolitionist.

(B) Slavery survived in the British Empire until the early 20th century.

(C) Quakers set up the first anti-slavery groups.

(D) The Royal Navy refused to stop ships carrying slaves.

24. Which TWO are political parties in the UK?

(A) Office Party

(B) Modern Party

(C) Conservative Party

(D) Labour Party

<div align="center">END OF THE TEST</div>

Answer (Paper 3):
答案及解析：

1. B

When Catherine was too old to give him another child, Henry VIII decided to divorce her, hoping that another wife would give him a son to be his heir.

當凱瑟琳太老了，無法再給亨利八世另一個孩子時，於是他決定與她離婚，希望另一個妻子可以給他一個兒子作為繼承人。

2. C

There are 33 local governments in London, and the Greater London Authority and the Mayor of London coordinate policies throughout the capital.

倫敦有33個地方政府，大倫敦管理局和倫敦市長協調整個首都的政策。

3. D

British combat troops left Iraq in 2009.

英國戰鬥部隊於2009年離開伊拉克。

4. B

The UK is governed by the parliament sitting in Westminster.

英國由西敏寺議會管轄。

5. A

Selling tobacco products (for example, cigarettes, cigars, and cigarettes) to anyone under 18 is illegal and a criminal offence.

向18歲以下的任何人出售菸草產品（例如香煙、雪茄和香煙）是違法的，是刑事犯罪。

6. C

The Normans used a system of land ownership known as Feudalism.

諾曼人使用的土地所有權制度稱為封建制度。

7. B

'All the world' s a stage' are lines from William Shakespeare' s play 《As You Like It》.

莎士比亞的戲劇《如願》的台詞是「整個世界都是一個舞台」。

8. B

In Elizabeth I' s time, English settlers first began to colonise the eastern coast of America.

In my Elizabethan era, British immigrants first began to colonize the East Coast of the United States.

在伊莉莎白時代，英國移民首先開始殖民到美國的東海岸。

9. B

In Wales the elected members, known as AMs, meet in the Welsh Assembly in the Senedd, Cardiff Bay.

在威爾斯，當選成員稱為AM，他們在卡迪夫灣Senedd的威爾斯議會開會。

10. B

In the 19th century, the medieval ' gothic' style became popular again. As cities expanded, many great public buildings were built in this style. The Houses of Parliament and St Pancras Station were built at this time, as were the town halls in cities such as Manchester and Sheffield.

在19世紀，中世紀的「哥德式」風格再次流行。隨著城市的擴大，許多大型公共建築都以這種風格建造。國會大廈和聖潘克拉斯車站都在此時建造，曼徹斯特和謝菲爾德等城市的市政廳也在此時建造。

11. A

There are famous gardens to visit throughout the UK, including Kew Gardens, Sissinghurst and Hidcote in England, Crathes Castle and Inveraray Castle in Scotland, Bodnant Garden in Wales, and Mount Stewart in Northern Ireland.

英國各地都有著名的花園，包括英國的Kew花園、Sissinghurst和Hidcote，蘇格蘭的Crathes和Inveraray城堡，威爾斯的Bodnant花園和北愛爾蘭的斯圖爾特山。

12. B

Admiral Nelson was in charge of the British fleet at Trafalgar and was killed in the battle.

尼爾遜海軍上將負責特拉法加的英國艦隊，並在戰鬥中喪生。

13. B

In England, Wales and Northern Ireland, serious offences are tried in front of a judge and a jury in a Crown Court. In Scotland, serious cases are heard in a Sheriff Court with either a sheriff or a sheriff with a jury.

在英格蘭、威爾斯和北愛爾蘭，最高法院的法官和陪審團要審理嚴重罪行。在蘇格蘭，治安官的首席陪審員或陪審團的首席陪審團審理嚴重案件。

14. A

The Scottish Parliament was formed in 1999.

蘇格蘭議會成立於1999年。

15. A

In the Bronze Age, people lived in round houses and buried the dead in tombs called round carts.

在青銅時代，人們居住在圓形房屋中，並將死者埋在稱為圓形推車的墳墓中。

16. A

Elected members of the Scottish Parliament are known as Members of the Scottish Parliament (MSPs).

當選的蘇格蘭議會議員稱為蘇格蘭議會議員（MSPs）。

17. B

During Halloween young people will often dress up in frightening costumes to play 'trick or treat'.

在萬聖節期間，年輕人通常穿著恐怖的服裝打扮起來，玩"搗蛋"。

18. A

The public can listen to debates in the Palace of Westminster from public galleries in both the House of Commons and the House of Lords.

公眾可以在下議院和上議院公共畫廊的威斯敏斯特宮旁聽辯論。

19. A and B

The television was developed by John Logie Baird in the 1920s. Tim Berners-Lee invented the World Wide Web in 1990.

電視是由約翰·貝爾德在1920年代開發的。科學家提姆·柏納·李於1990年發明了萬維網。

20. B and C

Ellie Simmonds won gold medals for swimming at the 2008 and 2012 Paralympic Games. Baroness Tanni Grey-Thompson has won 16 Paralympic medals for athletics.

伊莉·西蒙斯分別在2008和2012年夏季殘奧會上均獲得游泳金牌。湯普森贏得了16面殘奧會田徑獎牌。

21. B and C

In the UK Mothering Sunday is celebrated on the Sunday three weeks before Easter and Father's Day on the third Sunday in June. Children send cards and give gifts on these days.

在英國，母親節是在復活節前三週的星期日慶祝，而父親節則是在六月的第三個星期日。這些節日，孩子們發卡並送禮物。

22. A and B

There are responsibilities and freedoms which are shared by all those living in the UK. These include respecting and obeying the law, and treating others with fairness.

所有居住在英國的人都有責任和自由。其中包括尊重和遵守法律，以公平對待他人。

23. A and C

William Wilberforce played an important role in ending slavery, which was eventually abolished in the British Empire in 1833. The Quakers set up the first anti-slavery groups in the late 1700s.

威廉·威爾伯福斯在結束奴隸制方面發揮了重要作用，奴隸制最終於1833年在大英帝國廢除了。貴格會在1700年代後期建立了第一個反奴隸制組織。

24. C and D

The major political parties in the UK include the Conservative Party, the Labour Party and the Liberal Democrats.

英國的主要政黨包括保守黨、工黨和自由民主黨。

MOCK PAPER 4

The test consists of 24 questions, and you need to answer at least 18 correctly to pass.

1. **Who was the leader of the English Republic?**

 （A）King Richard III

 （B）Oliver Cromwell

 （C）Charles II

 （D）Charles I

2. **In accordance to census conducted on 2011, what percentage of people consider themselves Hindus?**

 （A）0.5%

 （B）1%

 （C）1.5%

 （D）3%

3. **How many devolved administrations in the UK?**

 （A）2

 （B）3

 （C）4

 （D）5

4. **Who is responsible for interpreting the law and ensuring a fair trial?**

 （A）Government

 （B）Police officer

 （C）Judiciary

 （D）Prime Minister and Members of Parliament

5. **How often do people who are 70 years old or older need to renew their driver's license?**

 (A) Every year

 (B) Every 2 years

 (C) Every 3 years

 (D) Every 5 years

6. **Where was Margaret Thatcher born?**

 (A) Buckinghamshire

 (B) Cheshire

 (C) Lincolnshire

 (D) Bedfordshire

7. **The Welsh government and National Assembly for Wales are based in Swansea.**

 (A) True

 (B) False

8. **Jenson Button is a famous Tennis player.**

 (A) True

 (B) False

9. **In 1824 King Edward I of England introduced the Statute of Rhuddlan, which annexed Wales to the Crown of England.**

 (A) True

 (B) False

10. Norway is a member of the European Union.

（A）True

（B）False

11. In the UK, alcohol cannot be sold to anyone under the age of 16.

（A）True

（B）False

12. The Duke of Lancaster was known as the Iron Duke.

（A）True

（B）False

13. Which of the following statements is CORRECT?

（A）Prime Minister can appoint the members of the Cabinet.

（B）Prime Minister cannot appoint the members of the Cabinet.

14. Which of the following statements is CORRECT?

（A）Argentina invade the Falklands Islands in 1981.

（B）Argentina invade the Falklands Islands in 1982.

15. Which of the following statements is CORRECT?

（A）December 26 is Boxing Day.

（B）December 31 is Boxing Day.

16. Which of the following statements is CORRECT?

（A）Alexander Fleming win the Nobel Prize in medicine for the discovery of the penicillin in 1941.

（B）Alexander Fleming win the Nobel Prize in medicine for the discovery of the penicillin in 1945.

17. Which of the following statements is CORRECT?

（A）The small claims procedure is an informal way of helping people to settle minor disputes.

（B）The small claims procedure helps people to make small home insurance claims.

18. Which of the following statements is CORRECT?

（A）In 1588 the English defeated a Spanish invasion fleet of ships.

（B）In 1588 the English defeated a German invasion fleet of bomber planes.

19. Which of the followings are Protestant Christian groups in the UK? (Choose TWO)

（A）Baptists

（B）Methodists

（C）Roman Catholics

（D）Buddhists

20. Which of the followings are British overseas territories? (Choose TWO)

（A）Ireland

（B）The Canary Islands

（C）St Helena

（D）The Falkland Islands

21. Which of the followings are the fundamental principles of British life? (Choose TWO)

（A）Only driving your car on weekdays

（B）Participation in community life

（C）Growing your own fruit and vegetables

（D）Tolerance of those with different faiths and beliefs

22. Which TWO are English Civil War battles?

（A）Waterloo

（B）Marston Moor

（C）Hastings

（D）Naseby

23. Which TWO of the followings do pressure and lobby groups do? (Choose TWO)

（A）Organise violent protests

（B）Influence government policy

（C）Assist MPs in their constituency work

（D）Represent the views of British businesses

24. What were the names of the TWO main groups in Parliament in the early 18th century?

(A) Whigs

(B) Labour

(C) Nationalists

(D) Tories

END OF THE TEST

Answer (Paper 4):
答案及解析：

1. B

Oliver Cromwell was the leader of the English republic.
奧利弗·克倫威爾是不列顛共和國的領導人。

2. C

In the 2011 census, 59% of people claimed to be Christians. The proportion of Muslims (4.8%), Hinduism (1.5%), Sikhs (0.8%), Judaism or Buddhists (all less than 0.5%) is much smaller.
在2011年的人口普查中，有59%的人聲稱自己是基督徒。穆斯林（4.8％），印度教（1.5％），錫克教徒（0.8％），猶太教或佛教徒（均少於0.5％）的比例要小得多。

3. B

There are three devolved administrations in the UK, include: the Welsh Assembly, the Scottish Parliament and the Northern Ireland Assembly.
英國共有三個權力下放的政府機構，其中包括：威爾士議會、蘇格蘭議會和北愛爾蘭議會。

4. C

The judge (collectively called the "judiciary") is responsible for interpreting the law and ensuring that the trial is conducted fairly.
法官（統稱為「司法機關」）負責解釋法律並確保審判公正進行。

5. C

Drivers can use their driving licence until they are 70 years old. After that, the licence is valid for three years at a time.

駕駛員可以使用駕照，直到他們70歲。此後，許可證一次有效期為三年。

6. C

Margaret Thatcher was the daughter of a grocer store in Grantham, Lincolnshire.

戴卓爾夫人是林肯郡格蘭瑟姆（Grantham）一家雜貨店的女兒。

7. B

Both the Welsh government and the National Assembly of Wales are located in Cardiff, the capital of Wales.

威爾斯政府和威爾斯國民議會都位於威爾斯首府卡迪夫。

8. B

Jenson Button is a famous Formula 1 driver.

簡森·巴頓是著名的一級方程式賽車手。

9. B

In 1284 King Edward I of England introduced the Statute of Rhuddlan, which annexed Wales to the Crown of England.

1284年，英格蘭國王愛德華一世制定了《羅德蘭規約》，該法案將威爾斯嫁給了英格蘭皇冠。

10. B

Norway is not a member of the European Union.

挪威不是歐洲聯盟的成員。

11. B

It is a criminal offence to sell alcohol to people under the age of 18 or buy alcohol for people under the age of 18. (There is one exception: people 16 years of age or older can drink while dining in hotels or restaurants.

向18歲以下的人出售酒精或為18歲以下的人購買酒精屬於刑事犯罪。（有一個例外：16歲或16歲以上的人可以在酒店或飯店用餐時喝酒。

12. B

In 1815, the French War ended with the defeat of Emperor Napoleon by the Duke of Wellington at the Battle of Waterloo. Wellington was called the Iron Duke and later became Prime Minister.

1815年，法國戰爭以惠靈頓公爵在滑鐵盧戰役中擊敗拿破崙皇帝而結束。惠靈頓被稱為鐵公爵，後來成為總理。

13. A

The Prime Minister (PM) is the leader of the ruling party. He or she appoints cabinet members and controls many important public appointments.

總理（PM）是執政黨的領導人。他或她任命內閣成員並控制許多重要的公共任命。

14. B

In 1982, Argentina invaded the Falkland Islands, which are British overseas territories in the South Atlantic.

1982年，阿根廷入侵了福克蘭群島，該群島是英國在南大西洋的海外領土。

15. A

Boxing Day is the day after Christmas, December 26, which is a public holiday.

節禮日是聖誕節後的第二天，即12月26日，是公眾假期。

16. B

Fleming won the Nobel Prize in Medicine in 1945 for his discovery of penicillin.

弗萊明因發現青黴素而於1945年獲得諾貝爾醫學獎。

17. A

The small claims procedure is an informal way of helping people to settle minor disputes without spending a lot of time and money using a lawyer.

小額索償程序是一種非正式的方法，可以幫助人們解決小糾紛，而無需花費大量時間和金錢來聘請律師。

18. A

The Spanish Armada (a large fleet of ships) attempted to invade England and restore Catholicism.

西班牙艦隊（一支龐大的艦隊）試圖入侵英格蘭並恢復天主教。

19. A and B

Baptists and Methodists are Protestant Christian groups. Other Protestant groups in the UK include the Church of England, the Church of Scotland, Presbyterians and Quakers.

浸信會和衛理公會是基督教的新教團體。英國的其他新教團體包括英格蘭教會、蘇格蘭教會、長老會和貴格會。

20. C and D

There are some British overseas territories in other parts of the world, such as St. Helena and the Falkland Islands. They are also associated with the United Kingdom, but not of the United Kingdom.

在世界其他地區，有一些英國海外領土，例如聖赫勒拿島和福克蘭群島。它們也與英國關聯，但與英國無關。

21. B and D

Participation in community life and tolerance of those with different faiths and beliefs are fundamental principles of British life. British society is founded on fundamental values and principles, which all those living in the UK should respect and support.

參與社區生活和容忍具有不同信仰和信仰的人是英國生活的基本原則。英國社會是建立在基本價值觀和原則之上的，所有居住在英國的人們都應該尊重和支持這些價值觀和原則。

22. B and D

The Battles of Marston Moor and Naseby during the English Civil War were both won by the parliamentary armies.

英國內戰期間的馬斯頓荒原戰役與那帕河谷戰役，均由議會軍贏得。

23. B and D

Pressure groups and lobby groups play an important part in the UK political process. Groups such as the Confederation of British Industry (CBI – which represents British business) and Greenpeace (which is concerned about environmental issues) lobby politicians to get their views across.

壓力團體和遊說團體在英國的政治進程中起著重要的作用。英國工業聯合會（CBI代表英國企業）和綠色和平組織（關注環境問題）等組織遊說政界人士，以表達他們的觀點。

24. A and D

From 1689 onwards there were two main groups in Parliament, known as the Whigs and the Tories.

從1689年開始，議會中有兩個主要團體，分別是輝格黨和保守黨。

MOCK PAPER 5

The test consists of 24 questions, and you need to answer at least 18 correctly to pass.

1. **Where can you find copies of the 'Hansard' ?**

 (A) In the Guardian newspaper

 (B) In large libraries and at www.parliament.uk

 (C) In bookshops

 (D) In any library

2. **In England, Wales and Northern Ireland, which court usually handles cases of children aged 10 to 17?**

 (A) High Court

 (B) Youth Court

 (C) Magistrates' Court

 (D) Sheriff Court

3. **How old do you need to enter a betting shop or gambling club?**

 (A) 16 years old

 (B) 18 years old

 (C) 20 years old

 (D) 21 years old

4. **Which flag has a diagonal white cross on a blue ground?**

 (A) The cross of St Andrew, patron saint of Scotland

 (B) The cross of St Patrick, patron saint of Ireland

 (C) The cross of St George, patron saint of England

 (D) The cross of St David, patron saint of Wales

5. **How long do Muslims fast for during Ramadan?**

 (A) A week

 (B) A month

 (C) Two weeks

 (D) Three weeks

6. **How many members are there in the Scottish Parliament?**

 (A) 60

 (B) 90

 (C) 120

 (D) 129

7. **Great Western Railway was the first major railway built in Britain.**

 (A) True

 (B) False

8. **In the 15th century, Henry Tudor, the leader of the House of Lancaster, became King Henry VI.**

 (A) True

 (B) False

9. **The Prime Minister appoints about 10 senior MPs to become ministers in charge of departments.**

 (A) True

 (B) False

10. Mary Peters was a talented athlete who won an Olympic gold medal in the pentathlon in 1976.

（A）True

（B）False

11. The capital city of Wales is Cornwall.

（A）True

（B）False

12. The Roman army left Britain in AD 400 to defend other parts of the Roman Empire and never returned.

（A）True

（B）False

13. Which of the following statements is CORRECT?

（A）The First World War lasted for three years.

（B）The First World War lasted four years.

14. Which of the following statements is CORRECT?

（A）Henry VII was the leader of the House of York.

（B）Henry VII was the leader of the House of Lancaster.

15. Which of the following statements is CORRECT?

(A) The Houses of Parliament and St Pancras Station were built in the 18th century, as were the town halls in cities such as Manchester and Sheffield.

(B) The Houses of Parliament and St Pancras Station were built in the 19th century, as were the town halls in cities such as Manchester and Sheffield.

16. Which of the following statements is CORRECT?

(A) There are now more than 61,000 volunteers helping to keep the National Trust running.

(B) There are now more than 16,000 volunteers helping to keep the National Trust running.

17. Which of the following statements is CORRECT?

(A) The population of the UK in 1851 was 20 million people.

(B) The population of the UK in 1851 was 10 million people.

18. Which of the following statements is CORRECT?

(A) 'A rose by any other name' is a line from William Shakespeare's play Romeo and Juliet.

(B) 'A rose by any other name' is a line from William Shakespeare's play Henry V.

19. Which TWO of the following are Christian religious festivals celebrated in the UK?

(A) Easter

(B) Halloween

(C) Christmas

(D) New Year

20. Which TWO are famous UK landmarks?

(A) Snowdonia

(B) Grand Canyon

(C) Loch Lomond

(D) Notre Dame

21. Which of the followings were associated with King Charles I and Parliament during the English Civil War? (Choose TWO)

(A) Tories

(B) Roundheads

(C) Luddites

(D) Cavaliers

22. Which TWO of the followings are the examples of Civil Law? (Choose TWO)

(A) Disputes between landlords and tenants

(B) Carrying weapons

(C) Discrimination in the workplace

(D) Selling tobacco

23. Which TWO new national bodies were established In the year of 1999?

 (A) House of Lords

 (B) Welsh Assembly

 (C) Scottish Parliament

 (D) English Parliament

24. Which of the following chambers form the UK Parliament? (Choose TWO)

 (A) House of Fraser

 (B) House of Lords

 (C) House of Commons

 (D) House of Representatives

END OF THE TEST

Answer (Paper 5):
答案及解析：

1. B

Proceedings in Parliament are broadcast on television and published in official reports called Hansard. Written reports can be found in large libraries and at www.parliament.uk.

國會的議事程序會在電視播出，並發表命為「議會議事錄」的正式報告。公眾可以在大型圖書館和www.parliament.uk中找到相關內容。

2. B

In England, Wales and Northern Ireland, if an accused person is aged 10 to 17, the case is normally heard in a Youth Court in front of up to three specially trained magistrates or a District Judge. The most serious cases will go the Crown Court.

在英格蘭、威爾斯和北愛爾蘭，如果被告的年齡在10到17歲之間，通常會在青少年法庭上審理此案，然後由三名經過特別訓練的地方法官進行審判。最嚴重的案件將由最高法院審理。

3. B

You must be at least 18 years old to enter a betting shop or gambling club.

您必須年滿18歲才能進入博彩商店或賭博俱樂部。

4. A

The cross of St. Andrew, patron saint of Scotland, is a diagonal white cross on a blue ground.

蘇格蘭守護神聖安德肋十字架是在藍色背景上有一個白色交叉。

5. B

Eid a-Fit celebrates the end of Ramadan, when Muslims have fasted for a month.

開齋節慶祝齋月的結束，穆斯林齋戒一個月。

6. D

The Scottish Parliament (MSP) has a total of 129 members, elected on a proportional representation system.

蘇格蘭議會（MSP）共有129名成員，按比例代表制選舉產生。

7. A

The Great Western Railway was the first major railway built in Britain.

大西部鐵路是英國建造的第一條主要鐵路。

8. B

In 1485, Henry Tudor, the leader of the House of Lancaster, became King Henry VII after defeating King Richard III of the House of York at the Battle of Bosworth Field.

1485年，蘭開斯特宮的首領亨利·都鐸在博斯沃思菲爾德擊敗約克宮的理查三世，成為亨利七世國王。

9. B

The Prime Minister appoints about 20 senior MPs to become ministers in charge of departments.

首相任命了大約20位高級議員擔任該部門的部長。

10. B

Mary Peterswas a talented athlete who won an Olympic gold medal in the pentathlon in 1972.

瑪麗·彼德斯（Mary Peters）是一位才華橫溢的運動員，他在1972年的五項全能運動會上獲得奧運金牌。

11. B

The capital city of Wales is Cardiff.

威爾斯的首都是卡迪夫。

12. B

The Roman army left Britain in 410 AD to defend the rest of the Roman Empire, but never returned.

羅馬軍隊於公元410年離開英國，保衛羅馬帝國的其餘部分，但從未返回。

13. B

The First World War lasted for four years (1914–1918).

第一次世界大戰持續了四年（1914-1918年）。

14. B

Henry VII was the leader of the House of Lancaster.

亨利七世是蘭開斯特宮的領袖。

15. B

The Houses of Parliament and St. Pancras Station were built in the 19th century, and the city halls of cities such as Manchester and Sheffield were also built in the 19th century.

國會大廈和聖潘克拉斯車站建於19世紀，曼徹斯特和謝菲爾德等城市的市政廳也建於19世紀。

16. A

There are now more than 61,000 volunteers helping to keep the National Trust running.

現在有61,000多名志願者幫助保持國家信託基金的運轉。

17. A

The population of Britain in 1851 was 20 million.

1851年，英國人口為2000萬。

18. A

The line in William Shakespeare's play "Romeo and Juliet" is "A rose by any other name."

莎士比亞戲劇《羅密歐與朱麗葉》中的台詞是 "A rose by any other name"。

19. A and C

Easter and Christmas are two Christian festivals. Christmas celebrates the birth of Jesus Christ, and Easter marks his death on Good Friday and his rising from the dead on Easter Sunday.

復活節和聖誕節是兩個基督教節日。聖誕節慶祝耶穌基督的誕生，復活節標誌著耶穌基督在耶穌受難日的死，標誌著他在復活節星期日從死裡復活。

20. A and C

Snowdonia is a national park in North Wales. Loch Lomond is in the Trossachs National Park in the west of Scotland.

雪敦山國家公園是北威爾斯的國家公園。洛蒙德湖位於蘇格蘭西部的特羅薩克斯國家公園。

21. B and D

Supporters of the king were known as Cavaliers and supporters of Parliament were known as Roundheads.

國王的支持者被稱為騎士，而議會的支持者被稱為圓顱黨。

22. A and C

Civil law is used to settle disputes between individuals or groups. Examples of civil law include housing law, employment law, consumer rights and laws related to the recovery of debt.

民法用於解決個人或團體之間的爭端。民法的例子包括住房法、就業法、消費者權利以及與追回債務有關的法律。

23. B and C

Since 1997, some power has been devolved from central government. In 1999 the Scottish Parliament and the Welsh Assembly were established, giving the people of Scotland and Wales more control over matters that directly affect them.

自1997年以來,中央政府已下放了一些權力。1999年,蘇格蘭議會和威爾斯議會成立,使蘇格蘭和威爾斯人民對直接影響他們的事情有了更多的控制權。

24. B and C

The UK Parliament is formed by the House of Commons and the House of Lords.

英國議會由下議院和上議院組成。

PART FOUR
常見問題

4.1
常見問題

1. 為什麼要參加和通過Life in the UK考試？

Life in the UK是非常實用的英語語言和英國生活基本知識考察，從2013年10月28日起申請英國永居和入籍的所有人必須通過這一考試，否則將功虧一簣，無法拿到永居簽證或入籍。

2. 英語不好，能不能通過Life in the UK考試？

Life in the UK是一項入門級的英語語言測試，測試重點在英國的歷史、文化、政治和風俗習慣。任何人即使英語程度不是太好，只要通過有效地指導，針對性的訓練，絕對可以通過考試。

3. 代考或作弊是通過Life in the UK的辦法嗎？

不是。魔高一尺，道高一丈，通過10年多的運作，Life in the UK的考試系統、監考方式和防作弊手段已經完全成熟完備，幾年前的監考漏洞已經完全補上。況且，一經發現代考或作弊，考試中心會立即報告

移民局。在簽證政策如此緊縮的前題下，移民局會立刻備案，您此後遞交的任何簽證將不會被通過，甚至會在有效簽證到期後拒絕入境數年。

4. 除了簽證外，學習Life in the UK還有好處？

Life in the UK不只是一項入門級的英語語言測試，更主要是對英國歷史、文化、政治、和風俗習慣的瞭解和認知。通過該考試的學習，您將對您決定定居或入籍的國家──英國──有一個簡單但全面的瞭解，明白這個國家的運行方式和系統，得知她的歷史和國家組成。

5. 在哪裡排期考試及應試？

你可以到www.lifeintheuktest.gov.uk在線排期考試，並只能在註冊並獲得批准的考試中心參加考試。

入籍英國考試全攻略 LIFE IN UK TEST

作　　者：Koo Sir

責任編輯：麥少明

版面設計：陳沫

出　　版：生活書房

電　　郵：livepublishing@ymail.com

發　　行：香港聯合書刊物流有限公司

　　　　　地址　香港新界大埔汀麗路36號中華商務印刷大廈3字樓

　　　　　電話（852）21502100

　　　　　傳真（852）24073062

初版日期：2020年11月

定　　價：HK$198 / NT$690 / GB £ 19.00

國際書號：978-988-13849-8-0

英國總經銷：Living Culture UK（電郵：LivingCulture@gmail.com）

台灣總經銷：貿騰發賣股份有限公司

　　　　　電話：(02) 8227 5988

網上購買 請登入以下網址：

一本 My Book One　　　超閱網 Superbookcity　　　香港書城 Hong Kong Book City

🌐 www.mybookone.com.hk　　🌐 www.mybookone.com.hk　　🌐 www.hkbookcity.com